Deutsche Guggenheim

Published on the occasion of the exhibition
Jeff Wall: Exposure

Organized by Jennifer Blessing

Deutsche Guggenheim, Berlin
November 3, 2007–January 20, 2008

ISBN 978-0-89207-369-6

Deutsche Bank & Solomon R. Guggenheim Foundation

Guggenheim Museum Publications
1071 Fifth Avenue
New York, New York 10128

Deutsche Guggenheim
Unter den Linden 13–15, 10117 Berlin

English edition available through
D.A.P./Distributed Art Publishers
155 Sixth Avenue, 2nd floor
New York, New York 10013
Tel: (212) 627-1999; Fax: (212) 627-9484

Distributed outside the United States and Canada by:
Thames & Hudson, Ltd.
181A High Holborn Road
London WC1V 7QX, United Kingdom

Design: Eileen Boxer / BoxerDesign
Editorial: Stephen Hoban, Helena Winston
Production: Minjee Cho, Melissa Secondino
Printed in Italy by Mariogros
Cover: Jeff Wall, *War game*, 2007 (detail) (pp. 48–49).

Photo Credits
Courbet, p. 54: © Scala / Art Resource, NY; De Sica, p. 20: © Janus
Films and Corinth Films; Delacroix, p. 8: © 2007 Art Resource,
NY, Photo: Erich Lessing; Evans, p. 52: Courtesy The Library of
Congress; Manet, p. 10: © The Samuel Courtauld Trust, Courtauld
Institute of Art Gallery, London; Marker, p. 24: © Janus Films and
Argus Films; Renoir, p. 22: © Janus Films; Unknown photogra-
pher, p. 55: © ullstein bild / The Granger Collection, New York;
Van Goyen, p. 56: © Bildarchiv Preussischer Kulturbesitz / Art
Resource, NY, Photo: Jörg P. Anders.

CONTENTS

Deutsche Guggenheim ◪

Deutsche Guggenheim is a unique joint venture between a corporation—Deutsche Bank—and a nonprofit arts foundation—The Solomon R. Guggenheim Foundation. Designed by American architect Richard Gluckman, the 510-square-meter gallery is located on the ground floor of the Deutsche Bank headquarters in Berlin. Since opening in fall 1997, Deutsche Guggenheim has presented three or four important exhibitions each year, many of which showcase a specially commissioned work by an artist. The exhibition program and day-to-day management of the museum is the responsibility of the two partners.

Deutsche Guggenheim joins the Solomon R. Guggenheim Foundation's other existing locations: the Solomon R. Guggenheim Museum in New York; the Peggy Guggenheim Collection in Venice; the Guggenheim Museum Bilbao; and the Guggenheim Hermitage in Las Vegas. Deutsche Bank regularly supports exhibitions in renowned museums, and since 1979 has been building its own collection of contemporary art under the motto "art at the workplace." The Deutsche Guggenheim initiative further represents a milestone in Deutsche Bank's advancement of the arts.

Exhibitions at Deutsche Guggenheim since its founding in 1997:

1997
Visions of Paris: Robert Delaunay's Series

1998
James Rosenquist: *The Swimmer in the Econo-mist**
From Dürer to Rauschenberg: A Quintessence of Drawing. Masterworks from the Albertina and the Guggenheim
Katharina Sieverding: Works on Pigment
After *Mountains and Sea*: Frankenthaler 1956–1959

1999
Andreas Slominski*
Georg Baselitz—Nostalgia in Istanbul
Amazons of the Avant-Garde:
Alexandra Exter, Natalia Goncharova, Liubov Popova, Olga Rozanova, Varvara Stepanova, and Nadezhda Udaltsova
Dan Flavin: The Architecture of Light

2000
Sugimoto: Portraits*
Förg—Deutsche Bank Collection
Lawrence Weiner: Nach Alles/After All*
Jeff Koons: Easyfun–Ethereal*

2001
The Sultan's Signature: Ottoman Calligraphy from the Sakip Sabanci Museum, Sabanci University, Istanbul
Neo Rauch—Deutsche Bank Collection
On the Sublime: Mark Rothko, Yves Klein, and James Turrell
Rachel Whiteread: Transient Spaces*

2002
Bill Viola: Going Forth By Day*
Kara Walker—Deutsche Bank Collection
Chillida/Tàpies
Gerhard Richter: Eight Gray*

2003
Kazimir Malevich: Suprematism
Richard Artschwager: Back and Forth/Up and Down
Tom Sachs: Nutsy's
Bruce Nauman: Theater of Experience

2004
Miwa Yanagi—Deutsche Bank Collection
Nam June Paik: Global Groove 2004
Robert Mapplethorpe and the Classical Tradition: Photographs and Mannerist Prints
John Baldessari: Somewhere Between Almost Right and Not Quite (With Orange)*

2005
No Limits, Just Edges: Jackson Pollock Paintings on Paper
25 Years of the Deutsche Bank Collection
Douglas Gordon's The VANITY of Allegory
William Kentridge: Black Box/Chambre Noire*

2006
Hanne Darboven: Hommage à Picasso*
Art of Tomorrow: Hilla Rebay and Solomon R. Guggenheim
Cai Guo-Qiang: Head On
All in the Present Must be Transformed: Matthew Barney and Joseph Beuys

2007
Divisionism/Neo-Impressionism: Arcadia and Anarchy
Affinities
Phoebe Washburn: Regulated Fool's Milk Meadow*
Jeff Wall: Exposure*

*Commissioned work by Deutsche Guggenheim

Foreword

From the outset, photography—treated paper exposed to light—has played a key role in our corporate collection and its focus on works on paper. In a tour of seven Latin American cities, the *More Than Meets the Eye* exhibition portrayed the immediacy and diversity of this medium with an impressive selection of about 300 photographic works of art from the Deutsche Bank Collection and the Deutsche Guggenheim's previous exhibitions of contemporary artists using photography have also been extremely well received.

In the past ten years, works by such notable artists as Hiroshi Sugimoto and Robert Mapplethorpe have been displayed here at the Deutsche Guggenheim. We are continuing this commitment to challenging and innovative photography with *Jeff Wall: Exposure*, an exhibition of work by the Canadian artist. Like the Sugimoto portraits exhibited in 2000, Wall's four large-format, black-and-white photographs—*Men waiting*, *Tenants*, *War game*, and *Cold storage, Vancouver*—were commissioned by the Deutsche Guggenheim and will be on display for the first time in Berlin. These four works will be complemented by five further pieces, including a number of light boxes. Together the nine photographs form one of the Deutsche Guggenheim's concise exhibitions that examine a specific theme or phase in an artist's work. This project has been shaped by Wall's desire to display these new pictures in combination with selected older works, juxtaposing black-and-white and color photographs in surprising and nuanced ways. The select group of works, chosen jointly by the artist and the curator, Jennifer Blessing, impressively showcases Wall's range of interests.

Each of Wall's black-and-white prints is fascinating—both visually and in terms of content—and will surely be the subject of much attention and investigation in the years to come. What is certain today is that Wall's work hauntingly lays bare one of art's greatest talents: the ability to make something visible that we have previously been unable—or unwilling—to see.

DR. TESSEN VON HEYDEBRECK
DEUTSCHE BANK AG

Preface / Acknowledgments

Jeff Wall: Exposure, a special exhibition commissioned by the Deutsche Guggenheim, presents publicly for the first time four large-scale, black-and-white photographs by artist Jeff Wall. This remarkable body of new work will be shown in conjunction with five earlier pieces—black-and-white photographs as well as transparencies mounted in lightboxes—to create an ensemble that resonates both formally and thematically. Wall has long been interested in the language of realism—in the values and aesthetics of representing daily life. All of the pictures on view realistically portray desolate places, or people in difficult circumstances typical of contemporary society. This focused exhibition will aptly demonstrate Wall's continuing interrogation of the history of photographic representation, and specifically the legacies of documentary photography and neorealist film.

This show marks the thirteenth commissioned project realized by the Deutsche Guggenheim since 1998, and the second completed in this, the museum's tenth-anniversary year. I am profoundly grateful to Dr. Tessen von Heydebreck, Member of the Board of Managing Directors of Deutsche Bank, for his continued visionary commitment to this program. And I am also extremely appreciative of the essential and unwavering support of the Deutsche Guggenheim given by Friedhelm Hütte, Global Head of Deutsche Bank Art.

I would like to acknowledge the generosity of the lenders who have kindly agreed to lend their important works to this exhibition, specifically Thomas Olbricht; Santiago Muñoz Bastide, Director of Art and Culture, Fundación Telefónica; and Marian Goodman. We are also grateful to Jörg Johnen and Gloria Moure, as well as Elaine Budin, Benita Röver, Tan Morben, Laura Ramón Brogeras, Ángeles Pérez Muela, and Brian Loftus for their help in arranging these crucial loans.

At the Solomon R. Guggenheim Museum in New York, numerous individuals have been instrumental to the realization of this exhibition. First of all, I would like to thank Jennifer Blessing, Curator of Photography, who oversaw the organization of the exhibition and catalogue. Valerie Hillings, Assistant Curator, and curatorial interns Dmitry Komis, Daniel Morris, and Ryan Reineck provided essential assistance at various stages of the project. I must also recognize Lisa Dennison, former Director of the Solomon R. Guggenheim Museum, for the important role she played in guiding this project and others for the Deutsche Guggenheim. I am additionally grateful for the invaluable efforts of Nancy Spector, Chief Curator; Sarah Austrian, General Counsel; Sara Geelan, Associate General Counsel; Alison Weaver, Director of Program and Operations, Affiliates; Ana Luisa Leite, Manager of Exhibition Design; Courtney Case, Assistant Registrar; and Mary Ann Hoag, Lighting Designer.

A team of talented individuals made this catalogue possible, chief among them are the Solomon R. Guggenheim Museum's outstanding Publications department: Elizabeth Levy, Director of Publications; Elizabeth Franzen, Managing Editor; Stephen Hoban, Assistant Managing Editor; Helena Winston, Associate Editor; Melissa Secondino, Production Manager; Minjee Cho, Associate Production Manager; and Jennifer Knox White, Editor must also be acknowledged. My sincere appreciation goes to the authors of the catalogue's essays, Jennifer Blessing and Katrin Blum, whose interpretations of Wall's new pictures are informative and engaging. Eileen Boxer has designed a handsome catalogue, for which I heartily congratulate her.

In Berlin, I would like to express my gratitude to Gallery Manager Svenja Gräfin von Reichenbach for her dedicated oversight of this show, which was made possible by the key support of two outstanding Associate Gallery Managers: Sara Bernshausen and Julia Rosenbaum. We also value the important contributions of Jörg Klambt, Bookstore Manager; Kathrin Conrad, Deutsche Guggenheim Club; Daniela Mewes, Office Manager; and Steffen Zarutzki and Ulrike Heine, Assistants. The excellent installation and conservation teams played a crucial role, and we extend our thanks to Uwe Rommel and his team of art handlers, Marjen Schmidt, Conservator, and Fabienne Lindner, Graphic Designer.

The staff at Wall's studio has been invaluable to this project, and the artist joins me in thanking them. Owen Kydd's measured anticipation of every detail of the installation in Berlin was essential. For his technical assistance during the catalogue production, I am grateful to Adam Harrison.

The person to whom we all owe the biggest debt of gratitude is, of course, Jeff Wall. He has created an extraordinary body of new work that both astounds and inspires us. I offer him my most profound thanks.

THOMAS KRENS, DIRECTOR
THE SOLOMON R. GUGGENHEIM FOUNDATION

JEFF WALL IN BLACK AND WHITE

JENNIFER BLESSING

This exhibition, *Jeff Wall: Exposure*, comes on the heels of two important retrospectives of the artist's work, one in Europe and the other in North America.[1] Appearing at five venues in total, these various edits of Wall's oeuvre, along with their comprehensive publications, have offered the opportunity to experience individual pictures in the context of his entire production.[2] Steeped in this history, as we have been these last two years, we now come to the four new, large-scale, black-and-white photographs at the Deutsche Guggenheim after the summa that Wall's retrospectives represent. It is natural, given this context, to consider where this new work fits in the artist's opus and upon which fresh paths he has embarked.

Wall's work invites this kind of contemplation, and more, for a number of reasons. Given their large scale and sharp focus, each picture is brimming with detail that rewards careful examination. Furthermore, the subjects are often enigmatic. The scene may have the air of familiarity—it may even seem like a snapshot, rooted in lived experience—but the more you look, the more you realize that there is something not quite right about the picture. You cannot put your finger on it, so you ask yourself why. Perhaps you become a detective and search for explanations, for something to read that will help you understand. If this is the case, then you will discover a vast literature on Wall's work, a very significant part of which consists of texts by the artist, including numerous interviews in which he offers insights into his working methods and influences.[3] There are tantalizing clues in these texts to help us understand the multiple layers of complexity that inform the production and reception of the work. All of this writing becomes a caption of sorts, a supplement that counters the intransigence of photographic representation, which itself fixes the innate ambiguity of reality when it captures an image. The photographic "slice of life" is like a still cut from a moving picture, and the fragmentary nature of both types of image—the photograph and the film still—imbues them with a certain mystery.

The word "exposure" in the title of this exhibition, then, suggests a process of uncovering, of bringing to light. In the case of this exhibition, the new works—and their configuration with somewhat older pieces—might be seen as new documents, new pieces of evidence to be added to the corpus of the artist's work, and thus new clues in the quest to understand (or layer the experience of) Wall's work.

"Exposure" also refers to the subject matter of the images in this show. Not unlike many other pictures in Wall's oeuvre, these new images depict the struggle of individuals in straitened economic circumstances to maintain a shelter, to keep a roof over their heads. Each image is a realistic presentation of an event that is a recognizable condition of contemporary society: a group of unemployed workers hoping to be selected for temporary jobs; a woman returning to her dreary apartment building, presumably after a hard day trying to make a living; or an empty lot inhabited by boys playing a game with toy guns, which on some level is a metaphor for the dog-eat-dog world of grown-up subsistence.

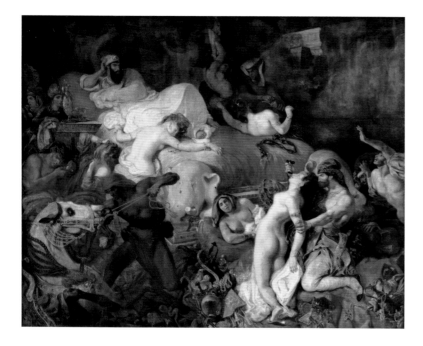

fig. 1 Eugène Delacroix, *Death of Sardanapalus*, 1827

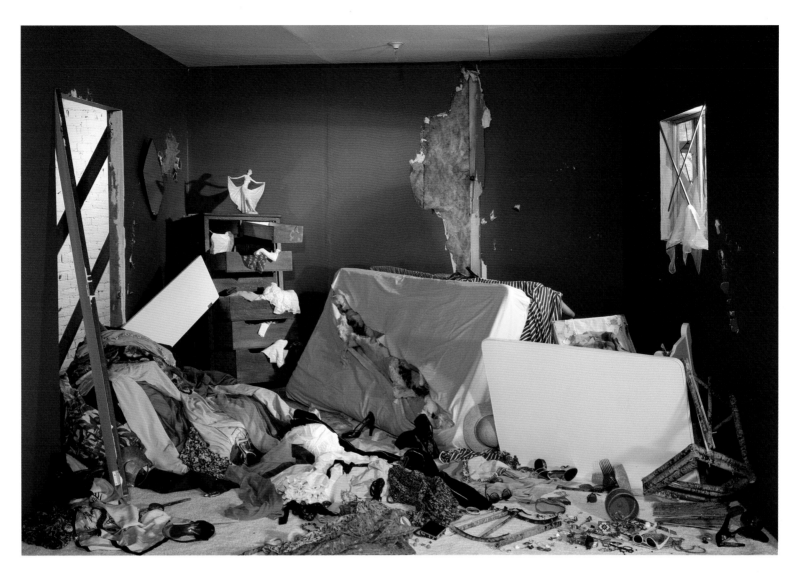

fig. 2 Jeff Wall, *The Destroyed Room*, 1978

In each case, the individuals in these pictures are exposed—to the elements and through their poverty. The one new photograph in the exhibition that does not include figures depicts a frigid cold-storage facility, an environment that quite literally threatens exposure for those who work there.

Finally, the word "exposure" refers to the kind of artist Wall is: he makes exposures. As a photographer, in other words, he uses light as his medium. Certainly Wall is a contemporary artist, but he is deeply engaged with the specific properties and history of his chosen artistic form, no more so than in his work in gelatin-silver—which includes the four new photographs in this exhibition.

Back Story

Wall was born in Vancouver, Canada, in 1946. As an undergraduate and graduate student at the University of British Columbia, he was a central protagonist in a small but vibrant local art scene with an international outlook. In 1970 he moved to London to study art history at the Courtauld Institute of Art, specifically to work on a thesis on the Dada photo-collagist John Heartfield. At this time Wall had stopped making art, having arrived at a kind of stalemate in his engagement with photo-conceptualism. During the three years Wall spent in London, he was profoundly affected by the influential post-1968 flowerings of engaged criticism and artistic production.[4]

Wall's first mature work as an artist, *The Destroyed Room* (1978; fig. 2), is a large-format color transparency mounted in a lightbox. The image shows a woman's bedroom that has been oddly upended. Like a number of the artist's early pictures, *The Destroyed Room* has a specific painterly precedent, Eugène Delacroix's *Death of Sardanapalus* (1827; fig. 1), which shows an Assyrian monarch ordering that he and his harem be put to death. Wall's picture

echoes Delacroix's animated diagonal axes, bloody hues, and violent theme, though Wall depicts destruction after the fact whereas Delacroix shows it in full throttle. Wall was interested in the context in which Delacroix created this painting, arguing that "the self-conscious parading of 'private' obsessions in the conventional framework of genres of grand public art" was a precursor of modern publicity, which has become, in some sense, our public art.[5] The subject of Delacroix's picture was an excuse to feed a taste for sex and violence, which has since moved from the realm of high art to that of mass consumer spectacle. The lightbox form of *The Destroyed Room* and the location in which it was first displayed—a gallery window—emphasize its relationship to advertising.

Wall has summarized the formative influences on his work as painting, cinema, and theory.[6] In the late 1960s and early 1970s, some of the most interesting and lively debates developed around artists, historians, and critics who were contesting and trying to reinvent artistic modes of representation, specifically in painting and film. There were arguments about the role of photography in nineteenth-century painting, about the nature of realism and its political implications, and about the visual representation of women as a manifestation of their subjugation, among others. The criticism that emerged in the United Kingdom, United States, and France had an urgency and passion that echoed the contentiousness of the period's political situation, and society at large in the wake of 1968. The world we live in now has been significantly shaped by this crucible of critique, though today the transformation is often taken for granted. Contemporary art and art history also reflect the impact of this period, even though the intricacies of the arguments that were made some thirty-odd years ago may seem arcane in retrospect. What is clear, and important, is that Wall was well versed in these arguments. They sustained him:

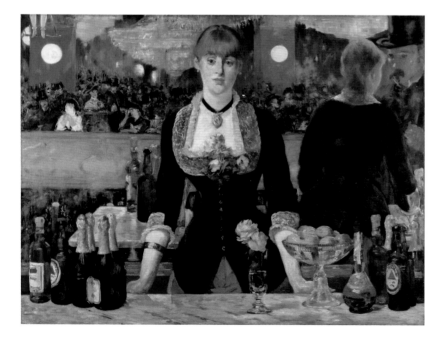

fig. 3 Édouard Manet, *A Bar at the Folies-Bergère,* 1882

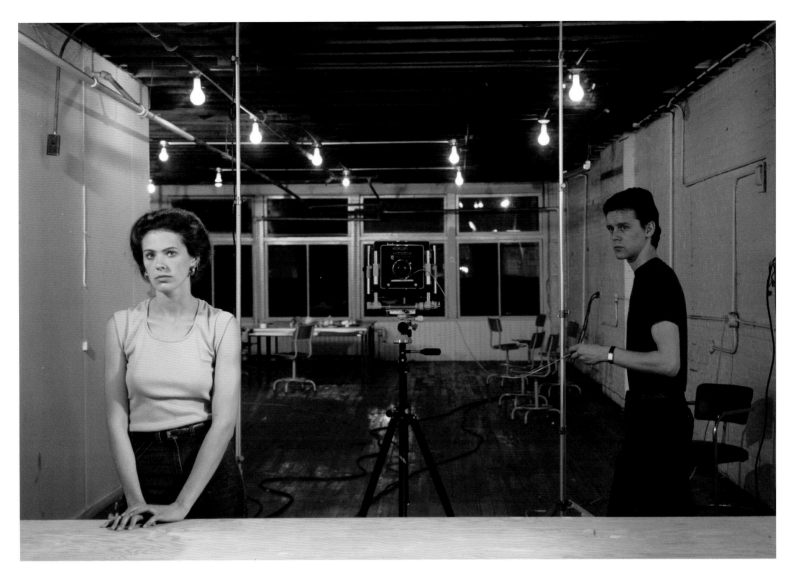

fig. 4 Jeff Wall, *Picture for Women*, 1979

he positioned his production within and against these discourses, and steadfastly maintained a compelling and reasoned independence from dogma. While pictures like *The Destroyed Room* do not *require* familiarity with his critical writing, they are certainly enriched by it.

Picture for Women (1979; fig. 4), Wall's next piece, exists in dialogue with Édouard Manet's *A Bar at the Folies-Bergère* (1882; fig. 3), a masterpiece in the collection of the Courtauld Institute, and the subject of much critical discourse around modernist representation as well as the role of women as the objects of a voyeuristic male gaze. As such, *Picture for Women* also demonstrates Wall's interest in the history of painting and the theoretical revisions of the 1970s, but it also marks his engagement with the cinema as a model for his form of photographic production.[7] Wall has commented that as a young artist he pointedly looked to film, as opposed to contemporary fine-art photography, as the model for his practice. Using the production methods of the cinema—staging scenarios suggesting a narrative by using actors, artificial lighting, and sets, and directing them as an artist-auteur—Wall basically created a film still, a moment pulled from a story like a frame from a reel. Unlike a film still, however, Wall's lightboxes suggest the cinema screen itself, in their scale and their luminosity. Thus he united the monumental size of nineteenth-century history painting with the public, yet oddly private, experience of watching a movie in a darkened theater, thereby pulling the cinema out of the dark, into the gallery, and into a space of fixed reverie rather than fleeting experience.

In the early 1980s, no longer having a studio in which to work, Wall was propelled to make pictures exclusively outdoors. These new photographs maintained a connection with nineteenth-century ideology in that Wall was striving to depict everyday life, the world as we know it—a modernist goal eloquently articulated in 1863 by Charles Baudelaire in his essay "The Painter of Modern Life," in which he argued that truly modern art had to represent the reality of life as it was experienced.[8] Baudelaire was arguing against historical costume set pieces, a staple of the Parisian Salon. His rationale later underpinned the acceptance of the Impressionists, whose art focused on contemporary urban and suburban subjects—people moving through railroad stations and city streets, dancers and their audiences at the ballet, and people relaxing and enjoying leisure time in parks. The Impressionists represented life as it was lived that moment, creating a sort of snapshot that featured real people rather than monarchs or allegorical figures. Wall has frequently mentioned the importance of Baudelaire to his project; he found in Baudelaire a validation for the content of his pictures.

The photographs Wall made in the street continue this strand of realism as it was found in the work of twentieth-century photographers who took shots of people in urban environments, from Henri Cartier-Bresson to Garry Winogrand. But unlike these photographers, Wall did not seek to catch an unexpected, fleeting moment, thereby elevating the random into the iconic. Instead, like a nineteenth-century painter, or more specifically, like a cinematographer, he set out to re-create events that he had witnessed himself. He had seen the gesture of racial disdain embodied in *Mimic* (1982; fig. 5) and reproduced it (mimicked it) by hiring and training actors to re-do the event he had witnessed. The result has a kind of truth one finds in a novel or a film, where lived experience incorporated or re-created in a fictional account conveys a sense of authenticity. Furthermore, the special relationship that cinema has to reality, the capacity for viewers to lose themselves in the narrative of the film, is one that is encouraged by the scale and the photographic realism (the focus) of the image on the screen. In order to make life-size, crystal-focused pictures of experiences from the street—in order, therefore, to bring daily life to life—Wall had to use large-format cameras that require set-ups and premeditation; he could not use the small 35mm cameras typical of traditional street photographers. "The spontaneous," Wall has remarked, "is the most beautiful thing that can appear in a picture, but nothing in art appears less spontaneously than that."[9]

When Wall came of age as an artist, photographers like Cartier-Bresson and his artistic descendents were held in rather low esteem by the contemporary art establishment. The reasons for this are complicated and fully untangling them is beyond the scope of this short essay, but it is worth trying briefly to touch upon some of them. After World War II, content—specifically, a sense of narrative—had been growing increasingly suspect, beginning with the rise of Abstract Expressionism and continuing through 1960s Minimalist painting and sculpture, which rejected the evocative and grand gestures—the trademark brushstrokes—of their artistic parents in favor of industrial processes. Subject matter was seen as impossibly subjective, and illusionism—the representation of perspectival space in two-dimensional work or of a life-size figure in sculpture—was considered a suspect form of trickery. Artists engaged in photo-conceptualism, as Wall was as a student, were interested in reducing the subjectivity of the artist by using mechanical and impersonal methods to create their work instead of the spontaneous and poetic techniques of photographers like Robert Frank and Winogrand. They chose to use photographs to document rather modest gestures and actions, mimicking the photography of scientific study and journalistic reportage.

At the same time, Structuralist filmmakers were attempting to define the nature of film by carefully examining the medium's formal properties. As a young artist who was interested in film and who considered making films himself, Wall was well aware of their work, but he had come to the conclusion that he wanted to tell stories—and this was one thing the Structuralists were not doing. So Wall found a way, as we have seen, of uniting the grand scale of nineteenth-century history painting with the interest in

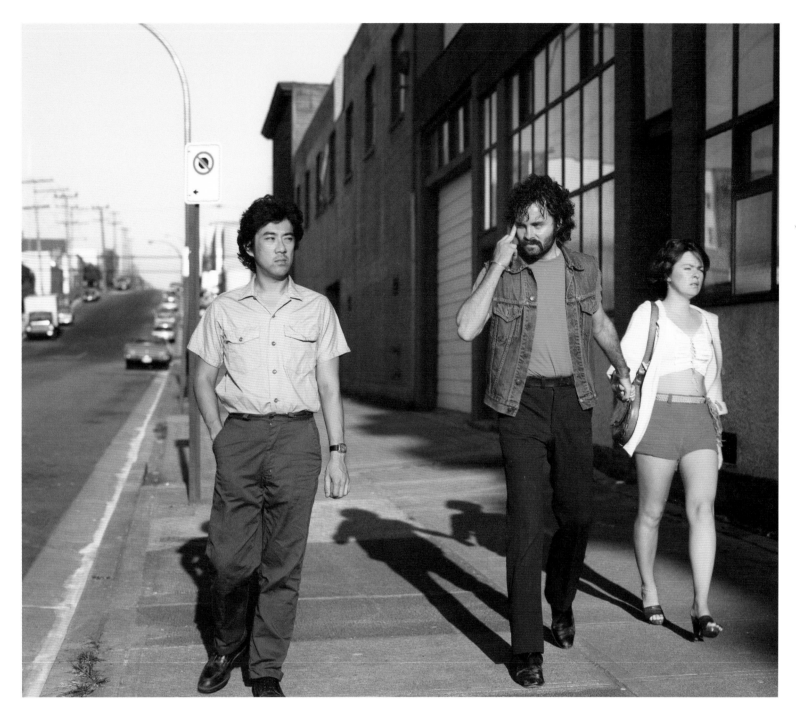

fig. 5 Jeff Wall, *Mimic*, 1982

modern life expressed by Baudelaire, along with the form and narrative of cinema, as articulated by its greatest realist directors.[10]

In 1987 Wall bought a small house in Vancouver and converted it into a studio. Three years later, with the photographs *Some Beans* (1990; fig. 7) and *An Octopus* (1990; fig. 8), which he shot in the basement of the house, he demonstrated his readiness to reengage the masters of fine-art photography. Earlier straight photographs, like *Steves Farm, Steveston* (1980, printed 1985) and the unstaged street photograph *Pleading* (1984, printed 1988), had the air of the cinema, the sense of being a slice of life or an extreme long (or establishing) shot. *Some Beans* and *An Octopus*, instead, are interesting hybrid works. They seem to be documentary photographs in that they record what is before the camera and do not involve actors, and yet they remain carefully staged and lit. They are not narrative in the traditional sense, but they are evocative and even dramatic. Wall has cited Paul Cézanne as an inspiration, but the influence of Wols and Walker Evans is also evident. Wall greatly augmented the scale of his work in comparison to that of these earlier artists however, lending a cinematic quality to what are essentially still-life subjects.

Wall has come to divide his oeuvre according to two modes of production: documentary photographs that record found locations and subjects and are typically devoid of figures; and cinematographic photographs that are staged for the camera and almost exclusively include figures.[11] Visually, the distinction is often unclear, just as the border between fact and fiction in photography, and especially in Wall's work, is easily muddied. *Swept* (1995; fig. 6), for example, does not depict anything more than an empty space, a void, a cellar that has been cleared and cleaned out, but the title, the past tense of a verb, indicates that something has happened. Like all of Wall's documentary photographs, there is a sense that something has either just occurred or is about to take place; the empty space appears to be a stage from which the actors have just exited or onto which they are about to step. Thus there remains a strong sense of narrative even in Wall's photographs without figures. As he has said: "I don't think that the presence of a human figure is required for there to be a depiction of an event, or an occurrence."[12]

Black and White in Wall's work
In 1996 Wall started producing large-scale, black-and-white photographs for the first time. He has said that he had been considering working in black and white for ten to fifteen years prior to making these first pictures, but it was not until he had set up his own darkroom that he was ready to begin shooting.

The first picture he made is *Volunteer* (1996; fig. 9), which shows a man who physically approximates the artist, mopping the floor of a drop-in center. Wall has said that in the mid-1980s he fought a battle with traditional

photography and lost.[13] Interestingly, in recounting the process of making this particular photo, he describes a contest of sorts with the actor who appears in the picture, whom Wall had hired to clean.[14] After two or three weeks of shooting, the artist and the actor fell into a kind cat-and-mouse game in which the actor might or might not move into the area in which he thought Wall liked to photograph him. The artist responded by "shooting blanks," in order to get the actor to think he wanted him in another place, so that eventually the actor would just relax into a routine and no longer care about the camera. In the end, Wall made a picture in which a lone man is cleaning the floor with an old-fashioned string mop that recalls a giant paintbrush, across from a stylized mural of a northern landscape. The monochrome tone of the image emphasizes the pure white of the figure's T-shirt, which echoes the white snowcaps on the mountains, the white-caps on the lake, and a seagull in the mural. It is tempting to see this photograph as a metaphoric visualization of Wall's "battle": just as Wall was confronting the tradition of gelatin-silver photography, a sort of alter ego faces off against a two-dimensional representation of reality—a (presumably) color mural, here transformed by the artist into black and white.

Wall has said: "I started doing black-and-white because when I first started working in color, which was in the '70s, I knew that, while color is important, it was also only one aspect of the medium."[15] Like others of his generation, Wall wanted to disassociate himself from aesthetic orthodoxies in the fine-art photography establishment, including a reverence for black and white and a distrust of color. As counterintuitive as it might seem today, the artificial palettes of the first color processes disturbed purists in both the photography and the film worlds. Black and white was felt to more accurately reproduce reality, while color was seen as distractingly sensational—good for the visual seduction of ads but bad for truthfully presenting the real world. Furthermore, color tended to diminish the immediacy of the play of light in an image, prioritizing palette over form, which seemed to purists to be a betrayal of a defining property of the medium.[16] When the Museum of Modern Art in New York mounted an exhibition of William Eggleston's color photographs in 1976, it was considered something of a scandal by the photography establishment. However, by the time Wall started making black-and-white pictures in 1996, color photography was firmly recognized as *the* form of contemporary art photography, a transformation in which he himself had played a large part.

By 1996 Wall was ready to look with fresh eyes at the masters of monochromatic representation. He was not going to look to painting, because painting had always been a polychromatic medium.[17] Exceptions such as Pablo Picasso's masterpiece *Guernica* (1937) only prove the rule: the key to its strength as a political statement lies in its tonality, for by painting in black and white, Picasso accessed the truth quotient associated with photographic

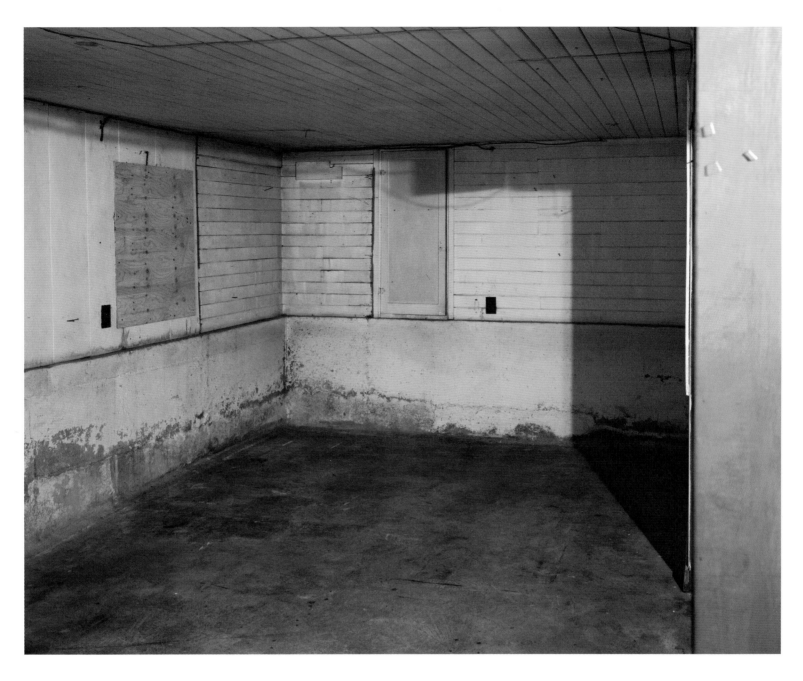

fig. 6 Jeff Wall, *Swept*, 1995

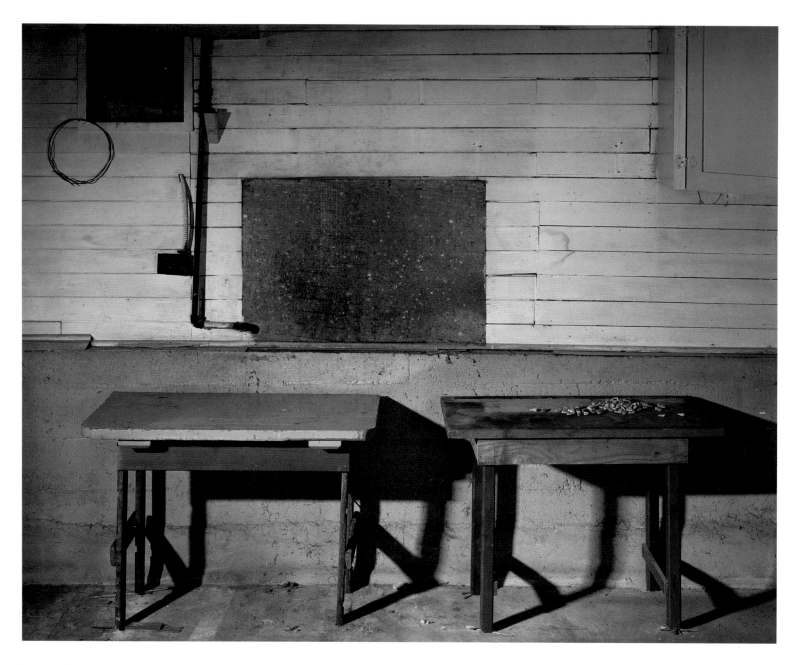

fig. 7 Jeff Wall, *Some Beans*, 1990

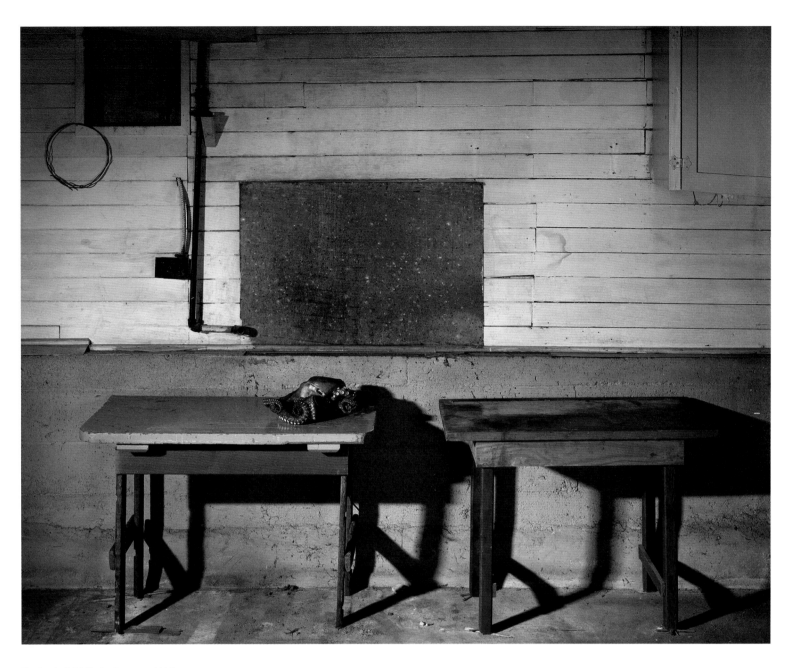

fig. 8 Jeff Wall, *An Octopus*, 1990

reportage.[18] The documentary role of photography and cinema has been intertwined from early on with both mediums, when gelatin-silver was the available technology. Monochrome has thus come to define a certain sense of authenticity.

Among those who understood the truth-value associated with black and white were the Italian neorealist filmmakers of the 1940s and 1950s, in whom Wall has long indicated his interest. At least at first, it was not the black-and-white medium of these films that concerned him, but rather the way in which directors like Roberto Rossellini and Vittorio De Sica were cinematographers of modern life. Their desire to present unvarnished, unidealized reality seemed to continue in film what Baudelaire had argued for in regard to painting. The methods the neorealists utilized to achieve this—location shooting (since no fabricated set could adequately capture lived experience) and the use of non-actors to achieve a sort of honesty devoid of dramatic affectations—had inspired Wall's working methods when he started shooting outdoors in 1982. Thematically, Wall's subject matter—his particular focus on modern life—aligns with that of the neorealists. Like them, he concentrates on real economic hardship: poverty, unemployment, prostitution, and black-market activities like the trade in illicit drugs. While the neorealists documented postwar Italy, Wall instead examines the contemporary world outside his studio in Vancouver.

In his catalogue essay for Wall's recent North American retrospective tour, Peter Galassi notes that two of the artist's first black-and-white photos "are among the most barren and forlorn of all his images of people at the margins of society."[19] One of these pictures, *Cyclist* (1996; fig. 11), obliquely recalls a masterpiece of Italian neorealism, De Sica's *The Bicycle Thief* (1948; fig. 10). The owner of the bicycle in Wall's picture seems as dependent on his vehicle for his livelihood as the protagonist of De Sica's film. There is the same quiet, yet unrelenting desperation in both narratives, and there is a similar kind of documentary impulse. The neorealists wanted to show "real" life as it was found on the street. Rossellini's *Open City* (1945), for example, was shot in Rome before the end of World War II and includes the reenacting of actual events, a method that is reminiscent of Wall's procedure in works like *Mimic* of re-creating scenes he has witnessed himself. Wall has used the term "near documentary" to describe the depiction of events that could have been witnessed even if they have not literally been seen. Though many of Wall's black-and-white images are cinematographic in that they are constructed scenarios, they all depict scenes from daily life, no more so than in his latest work.

When Wall started shooting in black and white in the mid-1990s, he seemed ready to explore not just the techniques and subjects of Italian neorealism, but also its form. Black and white is indelibly identified with neorealist films because color was, at that time, technically and economically unfeasible for filmmakers trying to capture spontaneous life on a shoestring budget. Subsequently, however, black and white became an aesthetic choice as well, since it signaled a refusal of opulence in the midst of Technicolor extravagance. Grainy black and white, which looked like a newsreel or a news photo, seemed more truthful, but also more appropriate to the downtrodden subjects of neorealist films and the hostile environments in which they lived.

Black and White at the Deutsche Guggenheim

Three Cinematographic Pictures with Figures
Ten years after he first exhibited a suite of large-scale, black-and-white photographs, Wall has created another group of such images.[20] In many ways these new pictures—specifically *Men waiting* (2006; pp. 40–41), *Tenants* (2007; pp. 38–39), and *War game* (2007; pp. 48–49)—seem especially indebted to a neorealist impulse. Of course, they embody processes and subjects that he has used for decades, but they also, when viewed within the context of his entire oeuvre, point to one of the major strands of Wall's current practice.

All of the pictures present images with which we are familiar, if we have ever experienced the economic periphery of any large city: men standing around near home-improvement stores, looking for work (*Men waiting*); well-worn, low-income housing (*Tenants*); and children playing rough games in which they prey upon each other (*War game*). Each of these images has echoes in earlier pictures by Wall (the frieze of men spread across the lower frame of *Men waiting*, for example, seems to have developed, in part, out of the multi-figure composition of *In front of a nightclub* [2006]), but taken together they are unified by a key formal similarity: in all three, the camera has pulled back from the scene so that the figures are further away and thus smaller in scale than most earlier black-and-white pictures. In other words, they are all extreme long shots, which provide a more expansive view of the context in which the figures exist.

To fully understand the significance of this, it is worth reviewing the variety of shots that are used by filmmakers to tell a story across the temporal arc of a movie. While there are many sub-variants, the most basic are: long shots, which range from the approximate distance between an audience and the stage in a theater to the point where the figures are so far away as to be tiny specks; full shots, in which the whole human body is just barely captured; medium shots, in which a figure is filmed from the knees or waist up; and close-ups. Filmmakers are highly dependent on medium shots to represent conversations (by interweaving images of participants listening or speaking) and on close-ups to convey emotion and build the audience's investment in specific characters. In Wall's oeuvre, there are very few medium or close-up shots.[21] He is arguably fairly uninterested in building

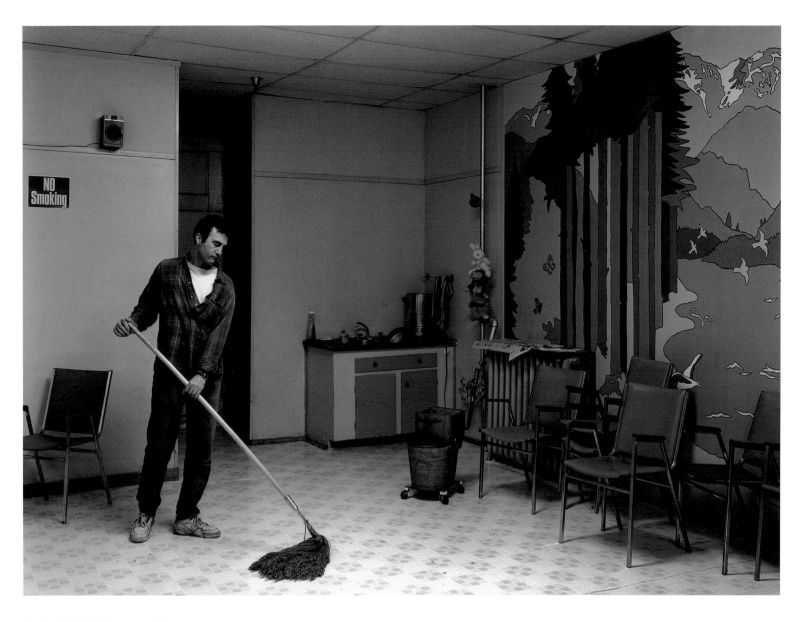

fig. 9 Jeff Wall, *Volunteer*, 1996

individual characters or examining their interior lives, and he is certainly not interested in the celebrity machine that has developed around the reception of the close-up.[22] Instead, when Wall depicts figures, he almost always uses a full or a long shot. This means that the figure is seen within a specific environment or context. As a result, the focus of the picture is more on the *type* of person depicted and the situation he or she is in, and seemingly less on an imputed insight into the emotional constitution of a unique individual.

Wall's locations, like those of neorealist films, are real places that he has scouted for his pictures.[23] In *Men waiting*, as in many other photographs, Wall used laborers to essentially portray themselves, though in a location of his choosing. He then shot them from afar in order to emphasize this environment. Neorealist films also typically privilege long shots, prioritizing context over persona. In the case of *Men waiting*—as in an epic picture, such as a Western—the sky takes up most of the frame. It seems to squash the squat buildings as well as the men in front of them, especially the figure at the far left, who is slumped over as if he bears the weight of the world on his shoulders. In a similar way, in the hunting scene of Jean Renoir's *The Rules of the Game* (1939; fig. 12), a movie that anticipated many neorealist technical innovations, the sky looms large over a tableau of aristocratic hunters, equating them with the small animals they hunt.[24]

Another way to look at this facet of Wall's production is to see the long shot as the descendent of history painting— of the grand, large-scale depiction of a momentous event, and all its participants. The close-up, in this comparison, is the descendent of the portrait painting, in which a specific individual is featured, sometimes to the complete exclusion of any contextual information. While Cindy Sherman investigates the latter—specifically, the legacy

of (female) portraiture as filtered through the cinematic close-up of melodrama (the woman's film or "weepy")— Wall's work epitomizes history painting as seen through neorealist film, particularly in these latest black-and-white images.

In the mid-1990s Wall's gelatin-silver photographs included either a single full-size (usually male) figure, or two figures, one of whom was almost completely obscured. *Night* (2001; fig. 13), like a number of the mid-1990s pictures, is a nocturnal scene. Unlike the earlier pictures, however, it is characterized by a more extreme long shot; thus the figures in the photograph are closer to the scale of the current work. The theme, a small group of homeless people exposed to the elements, also fits in with the present focus on shelter or lack thereof. The figures are, at first, difficult to make out as the scene appears to be devoid of even moonlight and is almost black. The site in the top half of the picture, which includes the small vignette of figures in the left middle ground, is elusively reflected in a sprawling puddle in the lower half. Straining to see, you can just make out a woman with lank hair, staring outside the frame of the image. A number of the figures in *Men waiting* gaze blankly like this, as well as the seated man in *Tenants*. The protagonist of *Tenants*, if there is just one, is the person wearing a backpack who appears to be returning home. This figure seems to be female, if the longish frizzy hair and headband adequately indicate her gender. Like so many figures in Wall's later work, and in the black-and-white pictures especially, her face is obscured. In some cases, for example in *Forest* (2001) and *Rear, 304 E 25th Ave., May 20, 1997, 1.14 & 1.17 p.m.* (1997), a woman's face is obliterated by hair; in others, like *Housekeeping* (1996), her entire back is turned to us.

Numerous commentators have noted Wall's interest in representing characters absorbed in their own thoughts,

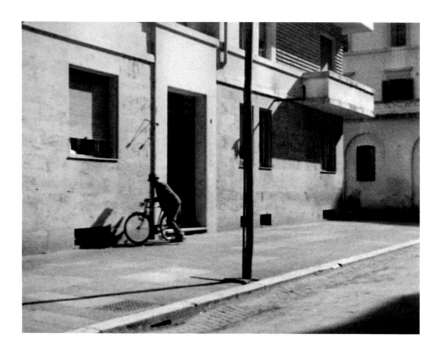

fig. 10 Vittorio De Sica, *The Bicycle Thief*, 1948

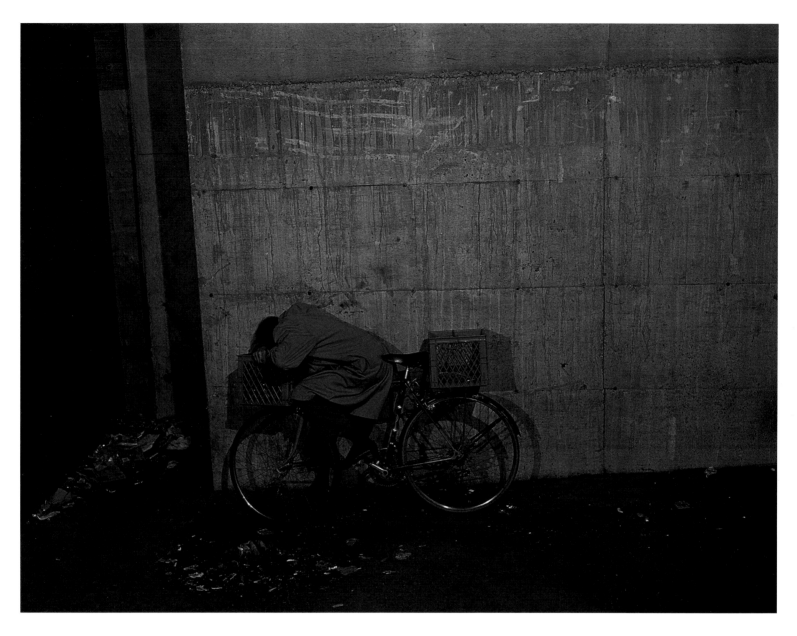

fig. 11 Jeff Wall, *Cyclist*, 1996

seemingly to the exclusion of the viewer.[25] While this is true of his work generally, it is especially notable regarding his representations of female subjects in the black-and-white photographs. His predilection for presenting women from the back or with their faces otherwise obscured seems to relate to his preference for emphasizing the character's context and de-emphasizing individuality. The notable exclusion of the subject's face in Wall's work discourages the viewer's identification with the image or objectification of the subject—two modes of spectatorship noted by feminist film theorists in the 1970s. Wall seems to continue to understand the problematic nature of representing the female subject and prefers to abstain from creating anything but extremely naturalistic depictions of female figures in contextual shots rather than close-ups.

On another level, however, Wall's images of figures that are turned away from us or are literally walking away suggest a psychic state of dejection and passivity. They also symbolically recall the ontology of photography itself, in that a transient state, a moment, is caught and fixed, but always, of course, ultimately lost. His many images of people coming and going (more frequently going, to be precise)—in other words, his depictions of arrested flux—are metaphors for the photograph itself.[26]

It is interesting in this regard to compare the backpack-bearing woman in *Tenants* to the four figures weighed down by their belongings in *Overpass* (2001; fig. 29). Under an ominous sky that pictorially overwhelms them, these travelers drag and carry their burdens to an unknown destination. They seem to transport their lives on their backs, to be itinerants without homes, exposed to threatening clouds. Though *Overpass* is a luminous color transparency, the overall tone of the sky, the sidewalk, and the travelers' clothes is a melancholy, almost

monochromatic blue-gray. It is only one step away from the pathos of the black-and-white picture *Tenants*, in palette as well as theme. *Overpass* also bears an uncanny resemblance to a famous image from Chris Marker's black-and-white film *La Jetée* (1962; fig. 14), which is made up almost entirely of still photographs. Whereas Wall seems to stop the moving film image in his pictures, Marker strings together a series of stills to form a continuous narrative in which the main character's traveling back and forth through time encapsulates the temporal mutability of still photography. Just as photographs haunt Marker's time traveler, Wall's *Overpass,* with its travelers, seems to be haunted by the memory of *La Jetée.*[27]

Wall has described the arrested moment of temporary recognition in *Passerby* (1996; fig. 17), which features a man craning to look back at someone who is running in the opposite direction, as a metaphor for the open/close of the camera's shutter.[28] In this photograph of coming and going, the strikingly illuminated "STOP" of a street sign in the picture literalizes the frozen gesture. A picture like *Passerby* memorializes the classic "decisive moment" of the documentary photographer, who waits and watches for just the right instant to capture an image that will transcend the momentary. It is a longstanding cliché that the photographer is like a hunter: both use a mechanical apparatus that arrests life, figuratively in the case of the camera and literally in the case of the gun. It is tempting to see Wall's new picture, *War game*, as an allegory of photography and the photographer's craft. *War game* features a static scenario of a boy guarding his prisoners, but as the viewer's eye moves in a kind of zigzag from middle ground further into the scene, one sees another group of boys, water guns drawn, searching for their opponents. These boys recall the two men in Wall's *A Hunting Scene* (1994), as well as the eponymous figure in *A man with a rifle* (2000; fig. 15), whose weapon is invisible

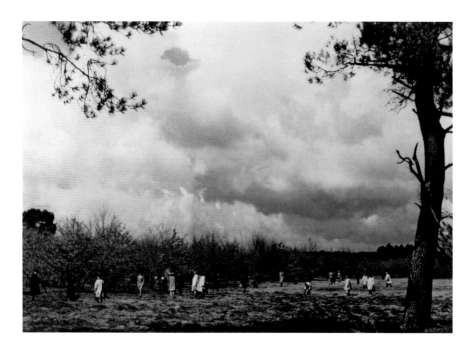

fig. 12 Jean Renoir, *The Rules of the Game,* 1939

22

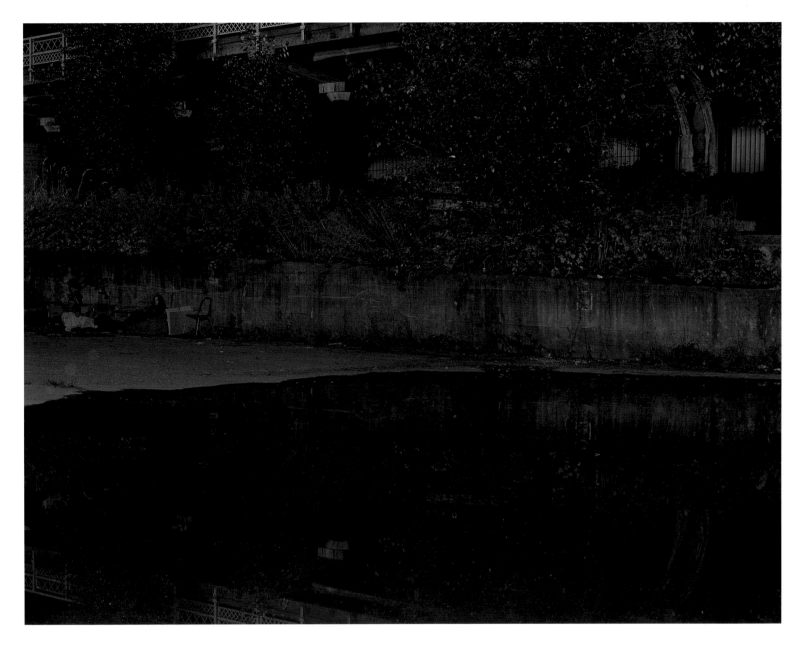

fig. 13 Jeff Wall, *Night*, 2001

(the children's guns in *War game* are instead transparent plastic and blend into the scenery).[29] All of these figures are searching for prey, as the photographer searches for an image or the cinematographer scouts a location. As an artist who is a photographer, Wall paints himself into an image like this. As in *Volunteer*, he is representing his craft as a sort of battle, or contest—or, in this recent photograph, a game.

The camera's ability to arrest life—to present the past-perfect "that-has-been"—is the basic ontological definition of photography and also forms a basic tenet of theorists of neorealist cinema, as it is perceived to be based in the logic of the photograph.[30] A certain melancholy about the passage of time is inherent in the image, no more so than in depictions of children—a neorealist subject par excellence because they symbolize a present that is fleeting—as they grow before our eyes and beyond the photograph from the moment it is taken.

In its depiction of boy-on-boy aggression, Wall's *The Goat* (1989; fig. 16) seems to predict the subject of *War game*. Thematically, both of these pictures recall the focus on children's lives in many neorealist films, and they specifically evoke scenes from Luis Buñuel's neorealist masterpiece *Los Olvidados* (1950). For example, a scene in which some boys attack a crippled man suggests *The Goat*; another in which they pretend they are both bullfighters and bull recalls the aggressive play in *War game*.[31] Formally, however, *War game* is closer to Buñuel's film, and to neorealist cinema generally (as are all of Wall's black-and-white pictures), than is *The Goat*. Buñuel's film, a kind of almost-documentary, is famous for its use of non-actors, a method espoused, of course, by Wall as well. In it, Buñuel represented a "forgotten" or "lost" generation of poor kids who lived in the streets of Mexico City. In *War game*, Wall instead seems to present an allegory of

loss itself: the lost time of the photograph is allegorized by the lost youth and by the remarkable blooming tree in the background, which is in the full flower of spring and will mature and die in the life cycle of the seasons, just as the children will age into adults and eventually die themselves. At the same time, the work's gelatin-silver process suggests a melancholic reverberation of the past in the present, as the medium is so clearly historically dated and, today, subject to extinction.

Wall further literalizes the living deadness of photography—the way it represents a life that is gone, in that the subject of the picture is fleeting—in the central scene of *War game*. The three prisoners who are jailed in a fort constructed of refuse seem to be playing dead—they lie prone on their stomachs—and yet one is laughing. Wall has famously depicted laughing cadavers in his picture *Dead Troops Talk (a vision after an ambush of a Red Army Patrol, near Moqor, Afghanistan, winter 1986)* (1992), as well as zombie types in a number of other images, including those described above as staring into space. Here, in a near-documentary mode, he continues to visualize a liminal zone between life and death. The prison-fort that the kids have constructed is also a kind of imaginary makeshift morgue. It is a resting place for the dead, like the cemeteries and graves Wall has frequently depicted.[32] Both Roland Barthes and André Bazin have written about the way time is "embalmed" or "mummified" in the photograph.[33] In Wall's images of the living dead, that quality is specifically visualized.

One Documentary Picture without Figures
Among the four new black-and-white pictures on exhibit at the Deutsche Guggenheim is one documentary image, *Cold storage, Vancouver* (2007; pp. 46–47). Devoid of figures or incident, this work is numbered among Wall's "eventless" pictures. And yet, as we have seen before, the

fig. 14 Chris Marker, *La Jetée,* 1962

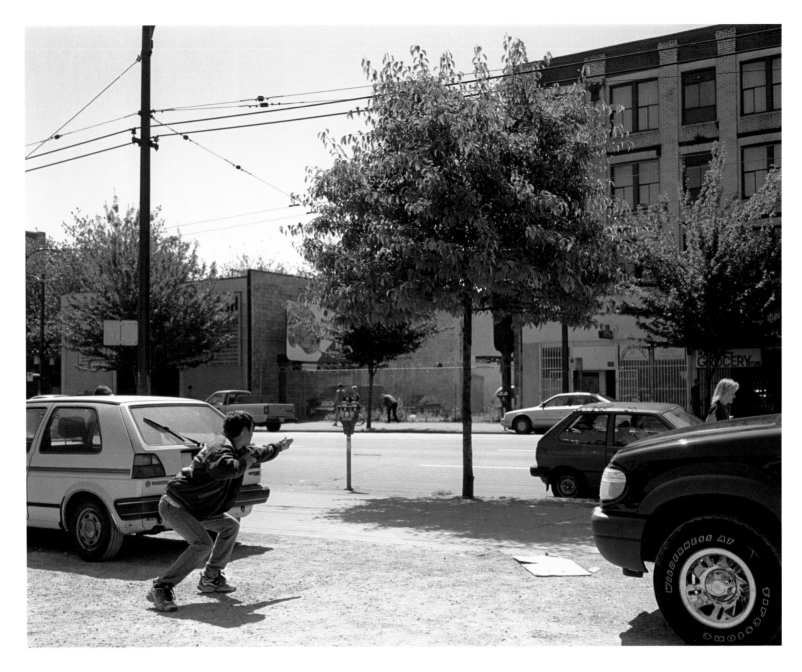

fig. 15 Jeff Wall, *A man with a rifle*, 2000

line between eventful and eventless in Wall's work is very porous, no more so than in this picture, which depicts a sort of majestic stage, "an arena in which to act."[34] At one point, Wall considered including a worker in this space. The picture that might have resulted would perhaps have been a pictorial brother to *Volunteer*. Instead, a ghostly presence haunts *Cold storage, Vancouver*, a specter who has moved through this space and is now gone.[35] We have a companion to *Swept*, a "corner" that is now bereft, devoid of the presence of a departed worker. The production of *Cold storage, Vancouver*, therefore, resembles that of *Dawn* (2001; fig. 19), in which Wall had intended to have some activity in the alley off to the side, "But as I worked on the picture, I realized that the event was extraneous and the picture was better without it."[36]

Wall has stated: "At the minimum, the making of the picture itself constitutes an occurrence, even a narrative, of its own making."[37] Certainly, *Cold storage, Vancouver* feels haunted by a narrative. The emptiness of the space suggests that it has been swept clean. It is, therefore, a place that is suspended in time: it has been emptied and cleaned and it will be filled again. Like the makeshift imaginary morgue in *War game*, it too is where dead things are stored on ice (preserved like a photograph), but in *Cold storage, Vancouver* the bodies have been moved, or have yet to be delivered. The site of *War game*, instead, is an empty lot that is now filled with children. Perhaps the ghost of a building that was once there haunts this space; perhaps it is haunted by the house that is to come. The temporary structure in the center of the image is both a reminder of what used to fill this empty lot and a harbinger of what will be there one day.

Cold storage, Vancouver questions the very nature of documentary in that its poetry is so artful as to defy the "found" quality of the place. Wall has said: "I've always been opposed to the idea that there is 'fiction' and then there is 'fact' in relation to photography. That has always been a very static and unrevealing way of looking at it. I do 'cinematography' because there are pictures I want to make that cannot be made any other way, as far as I can tell. But there are other pictures that can only be made as documentary photos, as straight photographs. But—also—there are aspects of documentary in my cinematographic pictures, and vice versa, and that's the way I like it."[38] In the context of his other new pictures, it is hard not to equate Wall's cold storage with an awe-inspiring landscape, to see the ice clinging to the ceiling as a sublime cloud-filled sky that presses heavily upon the earth. And yet the space is not gussied up or in any way prettified for the camera. The representation is intended to suggest that the scene is exactly as the artist found it. The image is therefore, in essence, photographic, in that the thing the camera does best is to record the world as it is. As Wall has said: "I also like dirty sinks, the soggy abandoned clothes I see in the alley behind my studio all the time, crusted dried pools of liquid and all the other picturesque things so akin to the spirit of photography."[39]

It was not really until the invention of photography that a value was placed on capturing mundane aspects of daily life, incidental gestures, forgotten and marginal places, and the ugly and banal. One of the criticisms of nineteenth-century painting that espoused realist values, from Gustave Courbet to Édouard Manet, was that it was often ugly, not artful.[40] These painters were criticized for honing in too closely to a kind of mundane truth, for not sufficiently transforming nature so as to make it transcend the moment and ultimately embody an edifying ideal. Often their paintings were disparaged for looking too much like a photographic image, specifically a daguerreotype. The counterargument was that ultimate truth (and therefore beauty) lay in being faithful to the world as we know it.

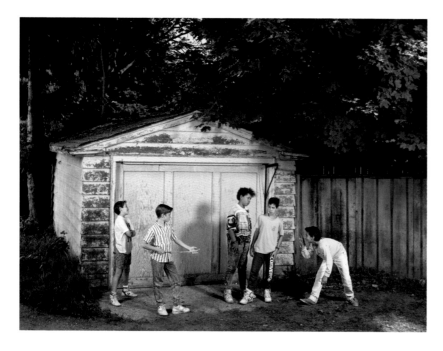

fig. 16 Jeff Wall, *The Goat*, 1989

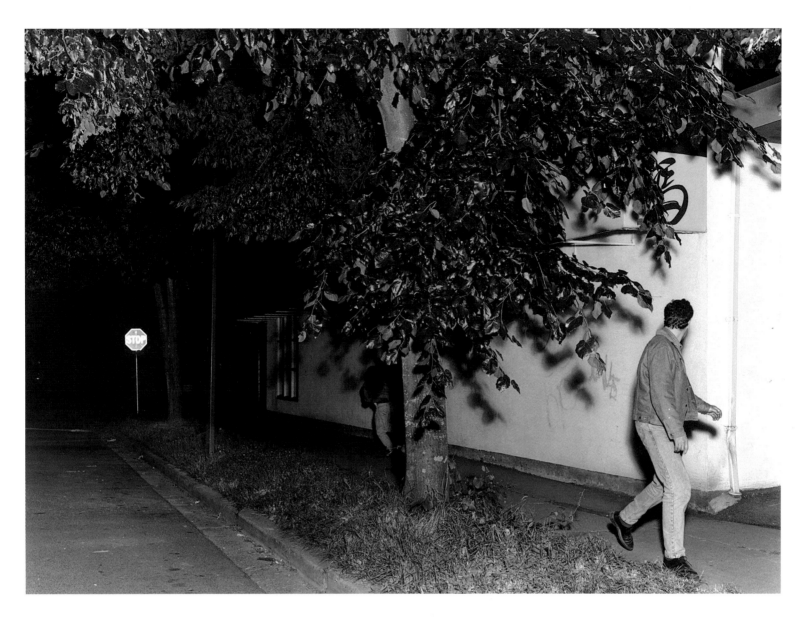

fig. 17 Jeff Wall, *Passerby*, 1996

Realist ideology in the nineteenth century, whether attached to the novel or to visual representation, continued to be debated well into the twentieth century. It has repeatedly been invoked by theorists who have tried to understand the nature of photography, and it was central to arguments about the nature of film as well. Wall has clearly continued to be nourished by a belief that the most despised and dejected aspects of modern urban life can not only yield magnificent images, but can tell a story.

Pictures like *Rainfilled suitcase* (2001; fig. 21) and *Blood-stained garment* (2003; fig. 18) depict found objects. They are documentary pictures, but they are also encapsulated street stories told by Wall. The point of view in these photographs, as well as in *Peas and Sauce* (1999; fig. 20), is insistent. You sense the artist-cinematographer holding a small camera and pointing down (or crouching down) to record what he has happened upon. There is the suggestion of struggle and of violence. *Rainfilled suitcase*, with its abandoned black bra floating in rainwater, its strewn-about litter, its blood-red wall, and its rakish diagonal, is as evocative of (feminine) distress as *The Destroyed Room*, with no protagonist to be found in either. It suggests the travails of one of the travelers in *Overpass*, who perhaps somehow lost her way and her belongings in the process. These documentary vignettes of street trash are picturesque in themselves, but they also signal that something has happened—an occurrence, an event in the past—and in this way they are as eventful as a photograph with figures that more obviously suggests a narrative. Wall's intense interest in found-documentary details like these always plays an important part in his cinematographic works as well. The remains of some peas and sauce in a take-out pan, for example, could have been snapped among the trash around the apartment building in *Tenants*. A rumpled, bloodstained garment might have been found in the abandoned lot of *War game*. Wall's

preference for long shots allows him to capture a wealth of such details, even in images with a dearth of incident. In *Dawn*, for example, although nothing particular is happening (except, implicitly, the sunrise, which is off-camera), the abandoned paper cup at the curb in the right foreground, as well as the graffiti on the dumpster suggest that people have been here.

Roland Barthes, writing about nineteenth-century fiction, describes the profusion of detail in realist novels as a stylistic device that convinces the reader of the authenticity of the narrative that unfolds in the text.[41] The same can be said of photography that privileges long shots, deep focus, and found locations, and of realist cinema that presents the world in all its particular detail, warts and all, using the tools of documentary film even when it presents a fictional narrative. In other words, realism is not only ideology but also style. Wall uses the same language of documentary when he creates his cinematographic pictures. Through evocative details, his narratives similarly convince his viewers that what they are seeing could easily have been stumbled upon by them, even if the stories were actually created for the camera.

In the nineteenth century, realist painting was born, in part, of *plein air* landscape studies. Artists left their studios, and the historical conventions of representation, to stand before their subject and try to paint what they saw. They tried to capture the play of sunlight through leaves and the billowy clouds before they scuttled by. At approximately the same time, cameras were developed that could catch in minute and precise detail every aspect of the world that was put before their lenses. Both photographers and painters were like scientists attempting to objectively observe the world around them and record it as accurately as possible. Courbet, who printed his "Realist Manifesto" in 1855, said: "I cannot paint an

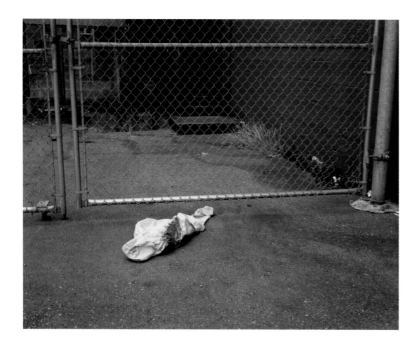

fig. 18 Jeff Wall, *Bloodstained garment*, 2003

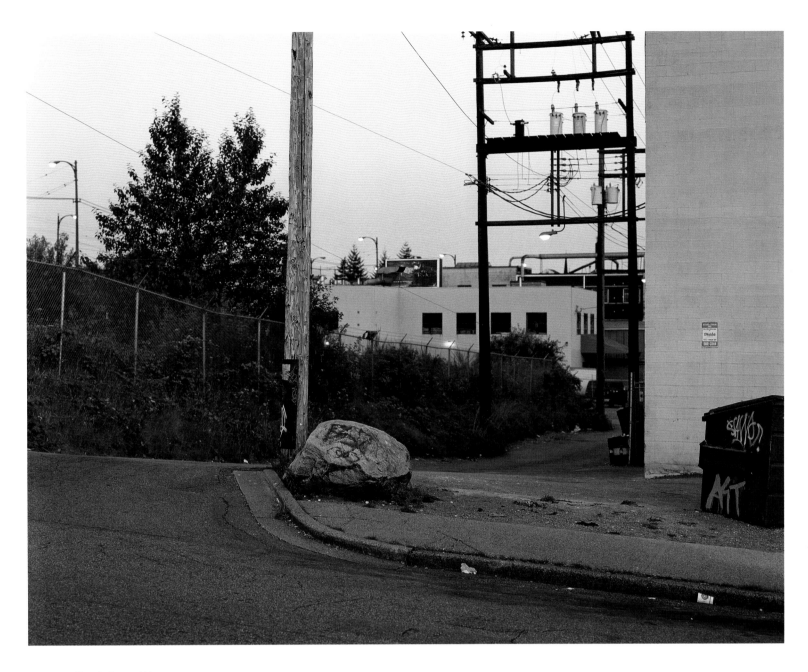

fig. 19 Jeff Wall, *Dawn*, 2001

angel because I have never seen one."[42] However, when he encountered some laborers on a drive, he wrote: "It's rare to meet the most complete expression of poverty, so an idea for a painting came to me on the spot."[43] Courbet's process of re-creating the scene he stumbled upon, which resulted in the painting *The Stonebreakers* (1849, destroyed 1945), included asking the men he had seen to pose for him. This striking precursor to the neorealist cinematic practice of using non-actors also finds its echo in Wall's "near documentary" approach, in terms of both process and subject matter.

Neorealist film of the 1940s and 1950s received its designation because of its affinities with nineteenth-century realism. The aesthetics of both movements were ideologically linked to left-leaning political support of the working classes and therefore elevated them to near heroic proportions. Formally, both were strongly committed to the representation of daily life. Two of the most important twentieth-century film theorists, Bazin and Siegfried Kracauer, both championed Italian neorealism as the ideal expression of the medium. Significantly, both writers investigated the ontology of photography in order to understand cinema.[44] They both strongly believed that the camera—whether still or moving—was best suited to capture reality as we know it, and that the most accomplished products of the camera would work with this key aspect of the medium rather than against it. "Originality in photography as distinct from originality in painting lies in the essentially objective character of photography," Bazin wrote.[45]

Wall has said: "Photography only gained its aesthetic or artistic identification through its re-reflection back through the cinema. I really think that, historically speaking, photography as an art form only became comprehensible—or the problematics of it as an art form became comprehensible—to itself when the cinema emerged as this large construct in which every possible photographic means could be validly put into play."[46] Certainly, film theorists like Bazin and Kracauer—and Barthes, who also wrote about both photography and cinema—saw a certain porousness between the two mediums, focusing on the nature of photographic representation and how it transformed the way that we see and think about the world.

In 1994 Wall remarked that "angels don't fly too well in photographs."[47] He was underscoring the weakness of photographic images that deviate from a basis in material reality. Bazin and Kracauer both felt that the camera's unique ability to represent the world—and by definition, modern life, and the world as we know it—positioned it to surpass any other art form. Like Courbet and Baudelaire, Bazin and Kracauer believed in the primacy of everyday life and in the capture of transient details as the best expression of our shared experience in the present. The damp sidewalk in Wall's *Concrete ball* (2002; fig. 22) speaks of the changeable weather in a particular time and place. The raking light and shadow play in his *Logs* (2002; fig. 23) notes the position of the sun at a particular time of day and season. The luminosity of the color picture suggests a glowing cinema screen, its promise of an eternal present moving before us stilled. The black-and-white print, instead, is imbued with the pathos of the history of this silvery medium. Its luminosity is of another order, founded in the eternally fixed rays of light that define its intense detail with a seemingly preternatural clarity.

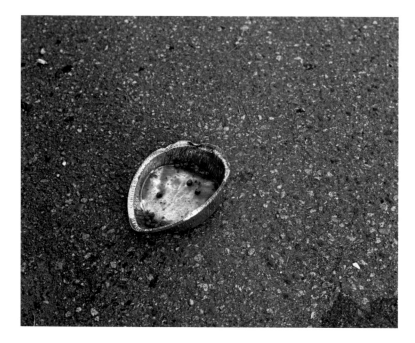

fig. 20 Jeff Wall, *Peas and Sauce*, 1999

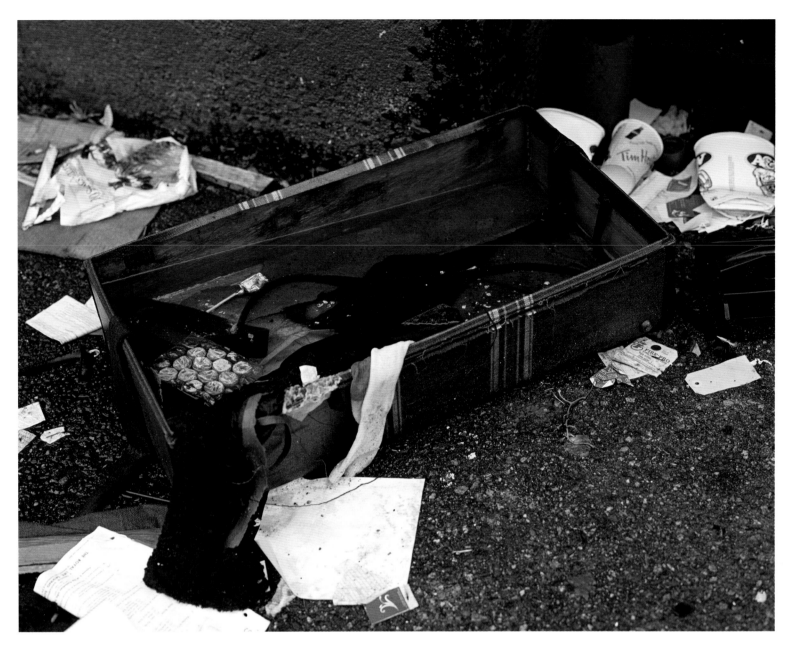

fig. 21 Jeff Wall, *Rainfilled suitcase*, 2001

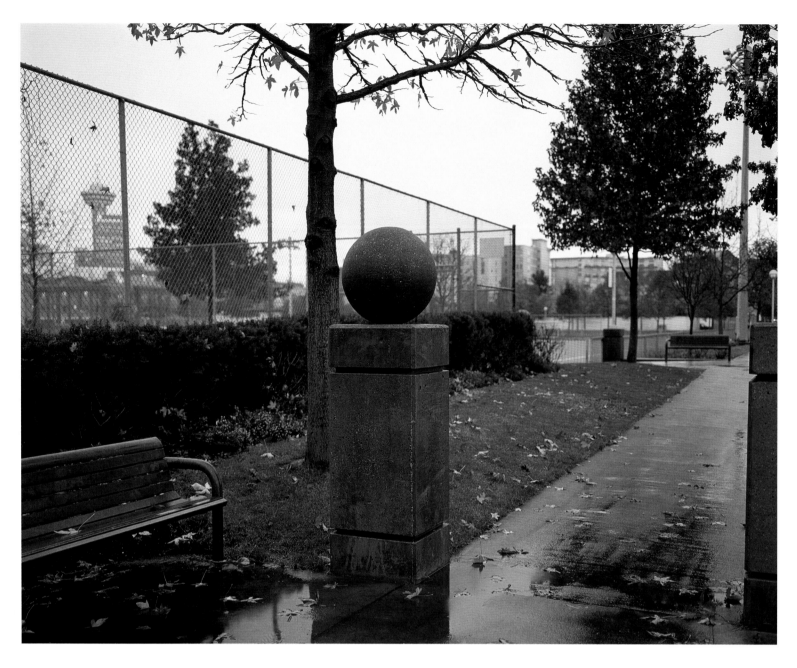

fig. 22 Jeff Wall, *Concrete ball*, 2002

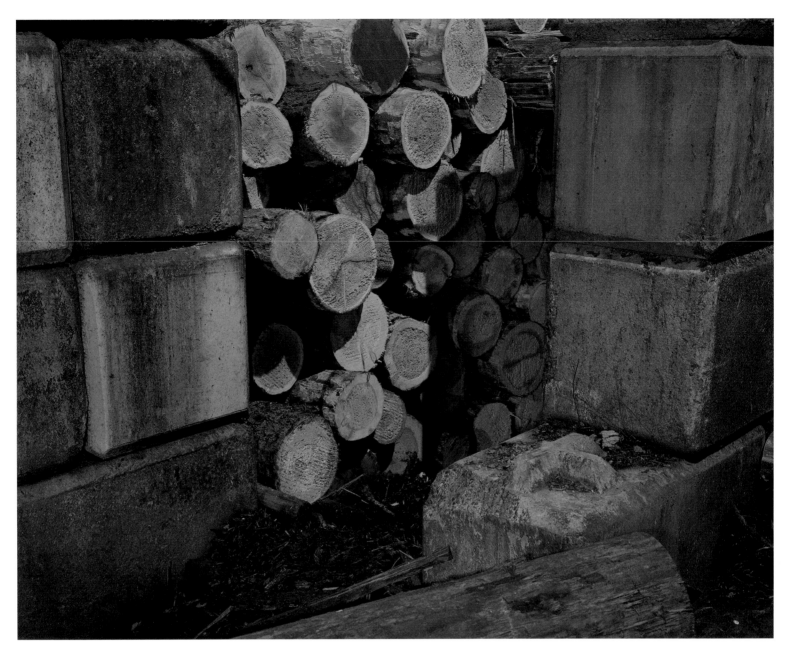

fig. 23 Jeff Wall, *Logs*, 2002

NOTES

1. *Jeff Wall: Photographs, 1978–2004*, Schaulager Basel (April 30–September 25, 2005) and Tate Modern, London (October 21, 2005–January 8, 2006); and *Jeff Wall*, Museum of Modern Art, New York (February 25–May 14, 2007), Art Institute of Chicago (June 30–September 23, 2007), and San Francisco Museum of Modern Art (October 27, 2007–January 27, 2008).

2. See Theodora Vischer and Heidi Naef, eds., *Jeff Wall: Catalogue Raisonné, 1978–2004* (Basel: Laurenz Foundation, Schaulager Basel; Göttingen: Steidl, 2005); Peter Galassi, *Jeff Wall*, exh. cat. (New York: Museum of Modern Art, 2007); and Sheena Wagstaff, *Jeff Wall: Photographs, 1978–2004*, exh. cat. (London: Tate, 2004).

3. See *Jeff Wall: Selected Essays and Interviews* (New York: Museum of Modern Art, 2007), as well as Jeff Wall, *Szenarien im Bildraum der Wirklichkeit: Essays und Interviews*, ed. Gregor Stemmrich (Amsterdam and Dresden: Verlag der Kunst, Fundus Books, 1997), and Jeff Wall, *Essais et entretiens, 1984–2001*, ed. Jean-François Chevrier (Paris: École Nationale Supérieure des Beaux-arts, 2001).

4. See Kerry Brougher, *Jeff Wall*, exh. cat. (Los Angeles: Museum of Contemporary Art; Zurich: Scalo, 1997), for a cogent review of Wall's artistic development.

5. For this and following quotations, see Jeff Wall, "The Destroyed Room, Picture for Women," in *Directions 1981*, ed. Miranda McClintic, exh. cat. (Washington, D.C.: Smithsonian Institution Press, 1981), p. 181; quoted in *Jeff Wall: Catalogue Raisonné, 1978–2004*, p. 275.

6. See, for example, Wall's public lecture at the Museum of Modern Art. Jeff Wall, "Jeff Wall Talks about His Work," 93 min. (February 26, 2007), MP3 http://www.moma.org/visit_moma/audio/2007/pub_prog/downloadAAPAA_2007.html.

7. Regarding this picture, Wall has said: "It was also a remake the way that movies are remade." Quoted in Jeff Wall, "Typology, Luminescence, Freedom: Selections from a Conversation with Jeff Wall," in *Jeff Wall: Transparencies* (New York: Rizzoli, 1987), p. 96; originally published in German in *Jeff Wall: Transparencies* (Munich: Schirmer/Mosel, 1986). Note also that the prominent image of a camera pointed at the audience resembles stills from Dziga Vertov's film *Man with a Movie Camera* (1929).

8. Charles Baudelaire, "The Painter of Modern Life," in *The Painter of Modern Life and Other Essays*, trans. and ed. Jonathan Mayne (London: Phaidon, 1964), pp. 1–40. Baudelaire's article was first published in installments in *Figaro* on November 26 and 28, and December 3, 1863. Wall has frequently discussed his interest in this essay; see, for example, David Shapiro, "A Conversation with Jeff Wall," in *Jeff Wall: Selected Essays and Interviews*, pp. 305–06 (originally published in *Museo*, no. 3 [Spring 2000]).

9. Wall, "Typology, Luminescence, Freedom," p. 100.

10. Wall discusses the nature of arguments regarding traditional photography, his changing relationship to it, as well as the influence of cinema in: Jeff Wall, "Frames of Reference," *Artforum* 42, no. 1 (September 2003): pp. 188–92.

11. Each work in the catalogue raisonné is identified according to this schema. The only documentary photographs with people that are more than small figures in a landscape are *Pleading* (1984) and *In the Public Garden* (1993); notably, both were shot with a 35 mm camera. The only cinematographic photographs without figures are *Destroyed Room*, *Some Beans*, and *An Octopus*.

12. Jean-Pierre Criqui, "Interview with Jeff Wall," in *Jeff Wall/Paul Cézanne*, exh. cat. (Paris: Musée d'Orsay, Argol, 2007), p. 37.

13. "In that latter part of the '80s I came to see that I had lost my battle with photography. That feeling was very strong by 1986 or 1987. I realized then that I was happy to have lost; the contestation was over and I was in fact a photographer." Wall, quoted in Jeff Wall, "Interview between Jeff Wall and Jean-François Chevrier," in *Jeff Wall: Selected Essays and Interviews*, p. 318; originally published in French in Wall, *Essais et entretiens, 1984-2001*.

14. Wall described this process in his Museum of Modern Art lecture, beginning at time 00:54:46. See Jeff Wall, "Jeff Wall Talks about His Work."

15. Shapiro, "A Conversation with Jeff Wall," p. 317. See also Jeff Wall, "Boris Groys in Conversation with Jeff Wall," in *Jeff Wall: Selected Essays and Interviews*, p. 297: "I knew all along that in order to stay involved with photography as I understood it, I'd have to resolve this exclusion. . . . Photographers of my generation began by fighting against what photography had become as a medium or art form, against how photography saw itself, and for years photographic work consisted chiefly in responses to the question of how to dissociate oneself from orthodox attitudes that had come to be equated with the aesthetics of photography. This process of dissociation, in my opinion, led to many significant innovations and to a general broadening of the discourse—altogether, it had a very positive effect, on both the form and handling of the medium. But after a while, I began to see more and more clearly that the struggle against received attitudes was taking place on photography's home ground, as it were, and that photographers could instead consider themselves as artists in other significant ways. I began to be able to see myself as a photographer in ways that ten or fifteen years earlier had not really interested me."

16. Significantly, the mural in *Volunteer* is devoid of modeling by light; its forms are flattened patches of color defined by contour outlines. In a way, its lack of definition mimics the limitation of color photography.

17. See Wall's comments on the relationship of black-and-white photography to "the medium of drawing" in Shapiro, "A Conversation with Jeff Wall," pp. 311–12.

18. Note also, in this regard, Picasso's monochromatic portrait painting of his children, *Two Seated Children (Claude and Paloma)* (1950, Private Collection, Geneva), which appears to relate to a family snapshot. It is also interesting to note that Wall's grand war statement, *Dead Troops Talk* (1992), has a very subdued, almost monochromatic palette. Furthermore, it was digitally composed from vignettes in a process not unlike Picasso's combination of different figural studies to create *Guernica*.

19. Galassi, *Jeff Wall*, p. 49. Galassi is referring specifically to *Cyclist* (1996) and *Rear, 304 E 25th Ave., May 20, 1997, 1.14 & 1.17 p.m.* (1997).

20. The first group of large-scale black-and-white pictures was shown at the exhibition *Documenta X* in Kassel, Germany (1997).

21. Significantly, the only close-ups in Wall's oeuvre all belong to series, thus somewhat diminishing the sense of individuality expected of portraiture: *Young Workers* (1978/1983), *Movie Audience* (1979), and *Children* (1988). It is important to note that cinematic conventions of framing do not neatly translate to the still photograph since the experience of the seated movie audience is fixed, while gallery-goers can move closer to the image to create an intimacy that is similar to the medium shot or close-up in a film by focusing on a detail in a picture. I thank Jeff Wall for suggesting this clarification.

22. See the thoughtful discussion about close-ups in Wall's work in Homay King, "The Long Goodbye: Jeff Wall and Film Theory," in *Jeff Wall: Photographs*, exh. cat. (Vienna: Museum Moderner Kunst Stiftung Ludwig Wien, 2003), pp. 110–27.

23. Wall specifically describes his process as "location scouting" in "Typology, Luminescence, Freedom," p. 97.

24. It is interesting to note that Cartier-Bresson was an actor and assistant director on this film. He found the location for the hunt scene and advised on its shooting because of his experience as a hunt leader in Africa. Cartier-Bresson's work often has a neorealist cinematic quality, certainly because of its documentary nature, but also in terms of its subject matter, as he, too, focused on the urban underclass. In order to get a job with Renoir he showed the director his photographs.

25. See, for example, Galassi, *Jeff Wall*, p. 51.

26. See the interesting discussion of the notion of "leave-taking" in Wall's work, in King, pp. 114ff.

27. Note in this regard Wall's comment about how genre subjects are haunted by past versions: "In that sense, there is always something spectral—ghostly—in the generic, since any new

version or variant has in it all the past variants, somehow. This quality is a sort of resonance, or shimmering feeling, which to me is an essential aspect of beauty and aesthetic pleasure." Quoted in Jeff Wall, "Arielle Pelenc in Dialogue with Jeff Wall," in *Jeff Wall*, eds. Thierry de Duve, Arielle Pelenc, and Boris Groys, revised and expanded ed. (London: Phaidon, 2002), p. 14.

28. "I just want to talk briefly about this one [*Passerby*], also a picture based on something I've seen. I mean, something that everybody's seen, which is someone hustling along the sidewalk for their own purposes and someone else giving them a glance. There's not much there, but it intrigued me because, I can't really explain it but, I like the idea, or I was intrigued by the idea, or hooked by the idea that you can get interested in someone's life for a hundredth of a second. Someone else's life interests you just for a moment. You give them a look, in a way you sum them up, you have and end your relationship with that person in that instant. I thought that was also something so photographic, it had something so much to do with the opening and closing of the shutter, in just a fraction of a second. So I wanted to make that picture on that basis." Wall, "Jeff Wall Talks about His Work," beginning at time 00:01:00.

29. See Jean-François Chevrier's fascinating comments about *A man with a rifle*, which he describes as "on the neorealist side of a reinvented street photography," in his essay "The Spectres of the Everyday," in *Jeff Wall*, eds. de Duve et al., pp. 180 and 182, including this: "The painter plays like the man with the imaginary rifle, like children playing war, within the tableau's safe space of pacification" (p. 182).

30. Regarding the articulation of 'that-has-been' as the essence of photography, see Roland Barthes, *Camera Lucida: Reflections on Photography*, trans. Richard Howard (New York: Hill and Wang, 1981), p. 77. Originally published as *La Chambre claire* (Paris: Editions du Seuil, 1980). See also King's comments, pp. 110–11.

31. *The Goat* suggests a striking affiliation with a familiar publicity still from *Los Olvidados*, though in Wall's picture the scapegoat is, like his attackers, a boy, while in Buñuel's scene he is a blind man. Significantly, the still appeared in Siegfried Kracauer's extremely influential study, *Theory of Film: The Redemption of Physical Reality* (London: Oxford University Press, 1960). It is worth noting that the practical difficulty of obtaining film stills from moving pictures has resulted in certain published images, like this one, attaining a kind of iconic status.

32. See *The Jewish Cemetery* (1980; printed 1985), *The Holocaust Memorial in the Jewish Cemetery* (1987), *The Flooded Grave* (1998-2000), and *Boys cutting through a hedge* (2003). Wall, quoted in "Arielle Pelenc in Dialogue with Jeff Wall," p. 13: "I have always thought of my 'realistic' work as populated with spectral characters whose state of being was not that fixed."

33. André Bazin, "The Ontology of the Photographic Image," in *What Is Cinema?* vol. 1, selected and trans. Hugh Gray (Berkeley: University of California Press, 1967), p. 242. See also Roland Barthes, *Camera Lucida*, p. 79: "For the photograph's immobility is somehow the result of a perverse confusion between two concepts: the Real and the Live: by attesting that the object has been real, the photo surreptitiously induces belief that it is alive, because of that delusion which makes us attribute to Reality an absolutely superior, somehow eternal value; but by shifting this reality to the past ('this-has-been'), the photograph suggests that it is already dead."

34. Harold Rosenberg, "The American Action Painters," *Art News* 51, no. 8 (December 1952), p. 22. This essay was reprinted in Rosenberg's book, *The Tradition of the New* (New York: Horizon Press Inc., 1959).

35. See "At Home and Elsewhere: A Dialogue in Brussels between Jeff Wall and Jean-François Chevrier," in *Jeff Wall: Selected Essays and Interviews*, pp. 290–91 (originally published in Wall, *Essais et entretiens, 1984–2001*) for Chevrier's provocative comments about haunting in *Housekeeping*, as well as his remarks in Chevrier, "Spectres of the Everyday," p. 173. In addition, Wall has said: "As I get older, I'm more interested in what is made invisible in the experience of the picture. This isn't easy to explain or describe; it's a feeling, a feeling that the picture doesn't just display its contents to the eye. It also leaves something undisclosed, something that cannot be seen in the viewing of the work but can

be experienced or sensed. Sensed as unseen." Wall, quoted in Jan Tumlir, "The Hole Truth: Jan Tumlir talks with Jeff Wall about *The Flooded Grave*," *Artforum* 39, no. 5 (March 2001), p. 117.

36. "Earlier [before *Dawn*], I had made my pictures without figures generally smaller." Wall, quoted in Criqui, "Interview with Jeff Wall," p. 31. "But I started making larger pictures of places or 'corners', again with no cinematography, no people, no events, pictures like *Swept* (1995), *Sunken Area* (1996), or *Green Rectangle* (1998). Then, with *Dawn*, as I said, I moved the camera further away from the things photographed and that was different again." Ibid., p. 33.

37. Ibid., p. 37.

38. Ibid., pp. 34, 36.

39. Wall, "A Note about Cleaning," reprinted in *Jeff Wall: Photographs 1978–2004*, p. 393. Originally published in *Architecture without Shadow*, exh. cat. (Seville: Centro Andaluz de Arte Contemporáneo; Barcelona: Centro de Cultura Contemporánia de Barcelona, 2000), p. 133.

40. The essential resource on realism in visual representation is Linda Nochlin, *Realism* (New York: Penguin, 1971). As an indication of the importance of theoretical debates about realism in the early 1970s, as well as the overlap in these discussions between the discourses of art history and film theory, note that *Screen* 13, no. 1 (Spring 1972) was dedicated to the issue of realism and included a critique of Nochlin's book; see Martha Kapos, "The Languages of Realism," pp. 79–85.

41. Roland Barthes, "The Reality Effect," in Barthes, *The Rustle of Language*, trans. Richard Howard (New York: Hill and Wang, 1986), pp. 141–48.

42. Quoted in Nochlin, p. 82.

43. Pierre Courhion, ed., *Courbet raconté par lui-même et par ses amis*, vol. 2 (Geneva: Pierre Cailler, 1950), p. 75, quoted in English in Jack Lindsay, *Gustave Courbet: His Life and Art* (New York: Harper and Row, 1973), p. 59, and quoted by Michael Fried, who adapted Lindsay's translation, in his *Courbet's Realism* (Chicago: University of Chicago Press, 1990), pp. 99–100.

44. Bazin, pp. 9-16; and Kracauer, "Photography," in his *Theory of Film*, pp. 3–23. Both essays are reprinted in *Classic Essays in Photography*, ed. Alan Trachtenberg (New Haven, Conn.: Leete's Island Books, 1980).

45. Bazin, p. 241.

46. Quoted in Jeremy Millar, "Jeff Wall: Digital Phantoms," *Creative Camera*, no. 326 (February/March 1994), p. 24. Wall continues on p. 25: "So, I see the cinematic as the place in which an imaginary subject can be made visible as a document—in fact, that's almost a definition of the cinematic effect, something that isn't real, appearing as immediate as a documentary."

47. Jeff Wall, "Angels Don't Fly Too Well in Photographs: Vik Muniz Interviews Jeff Wall," *Blind Spot*, no. 4 (1994), unpaginated.

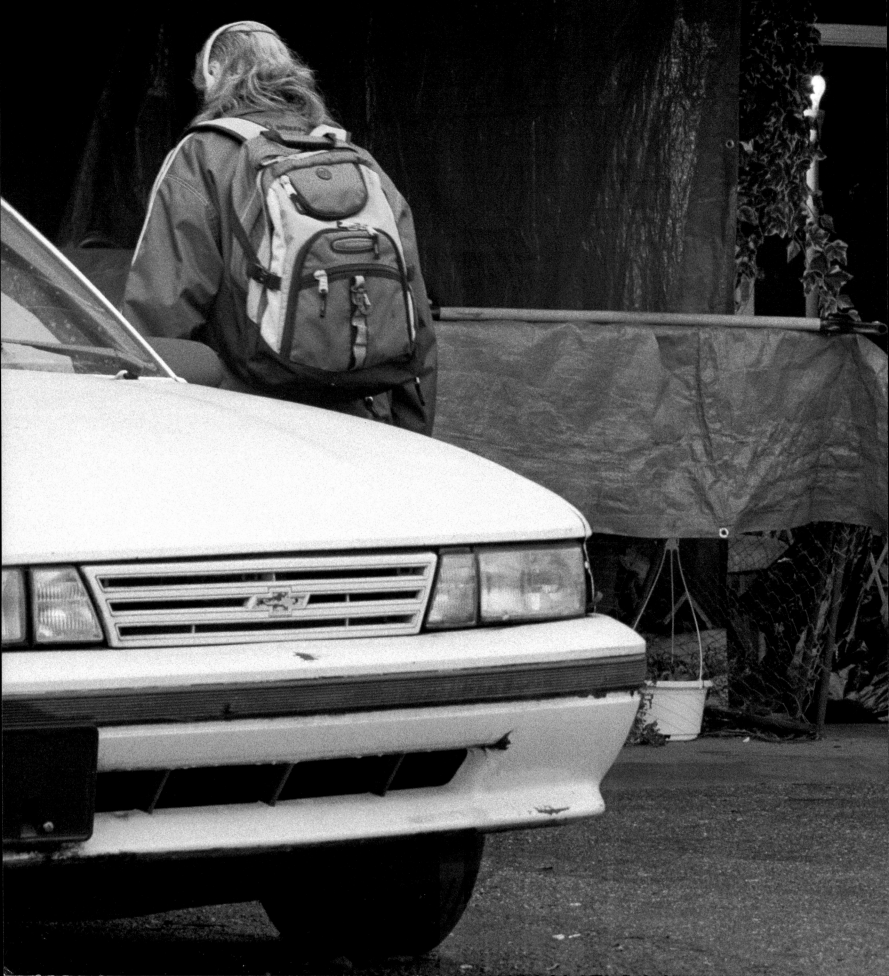

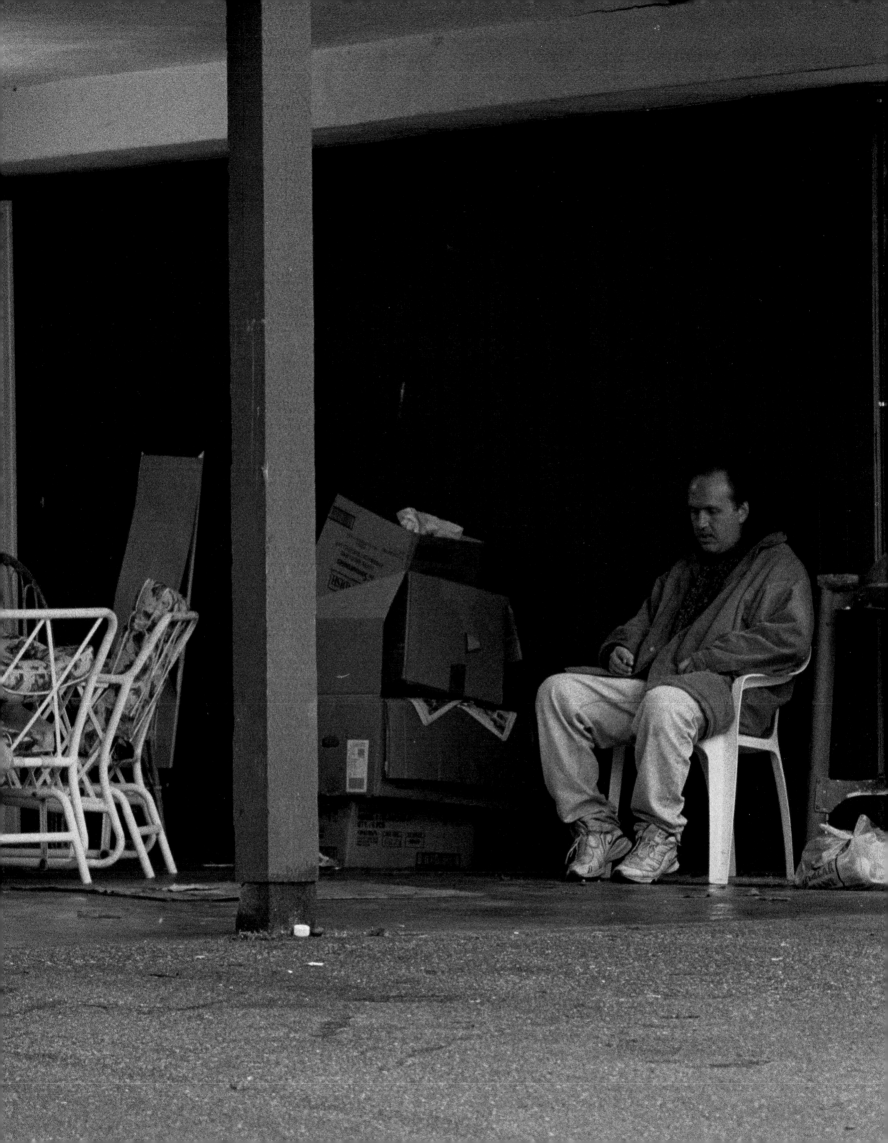

TENANTS
2007
Gelatin-silver print
255.4 × 335.3 cm

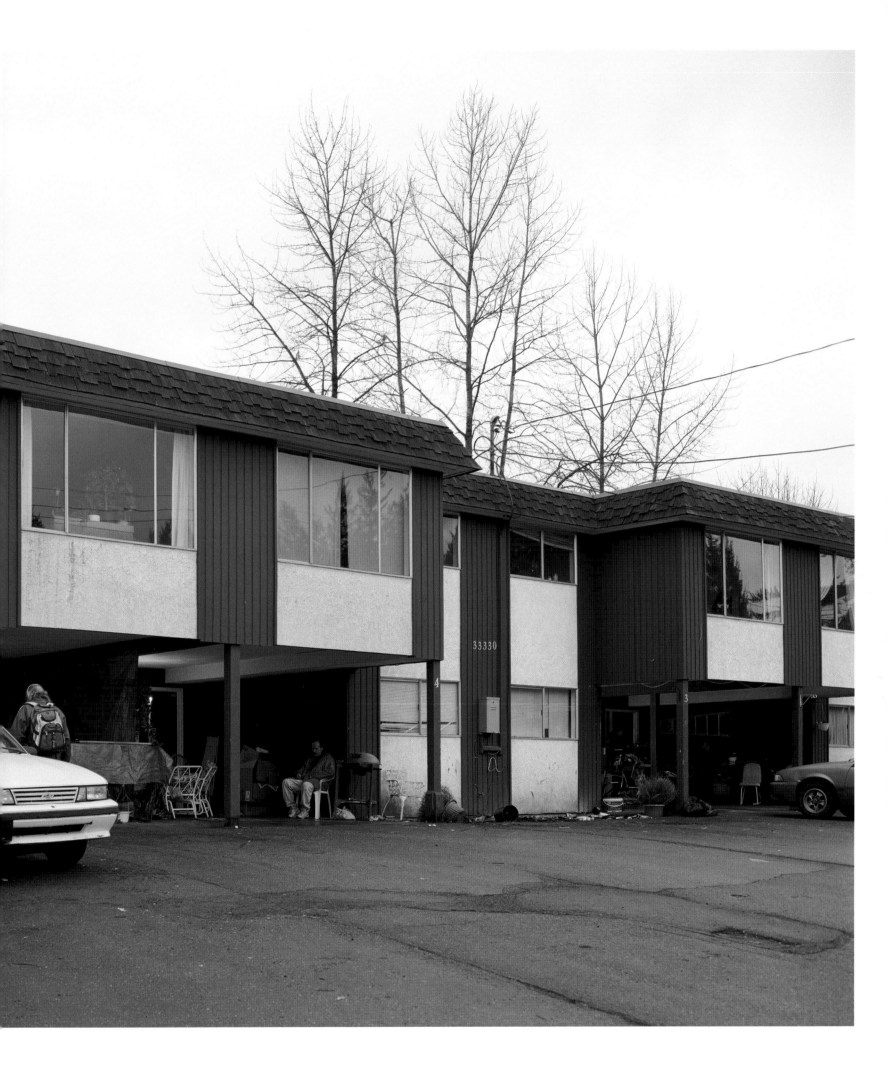

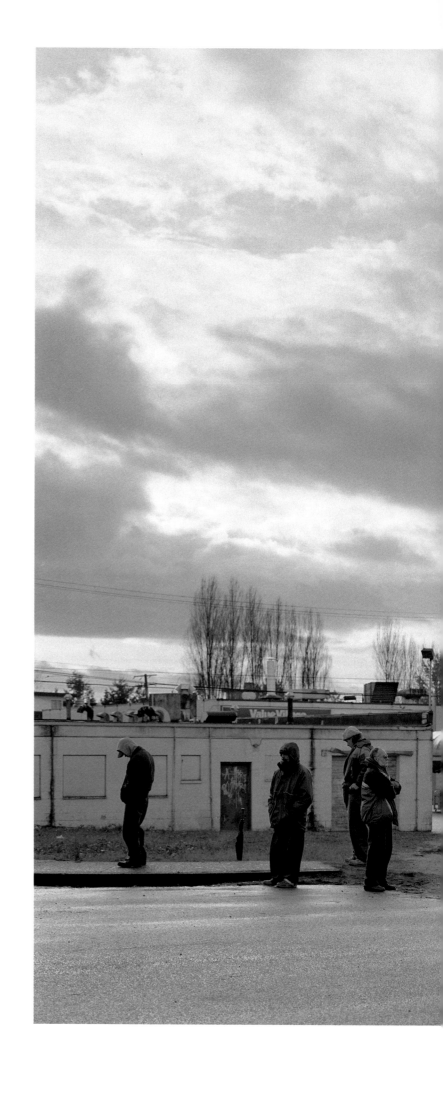

MEN WAITING
2006
Gelatin-silver print
262 × 388 cm

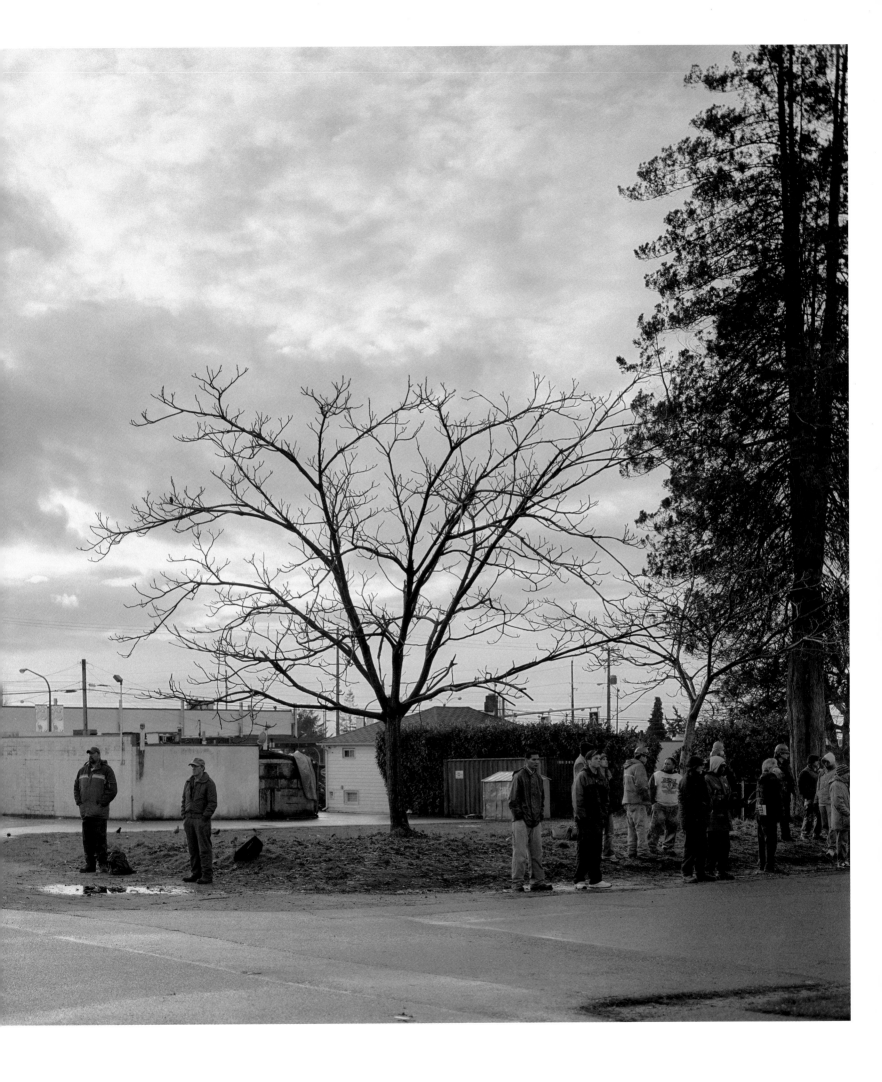

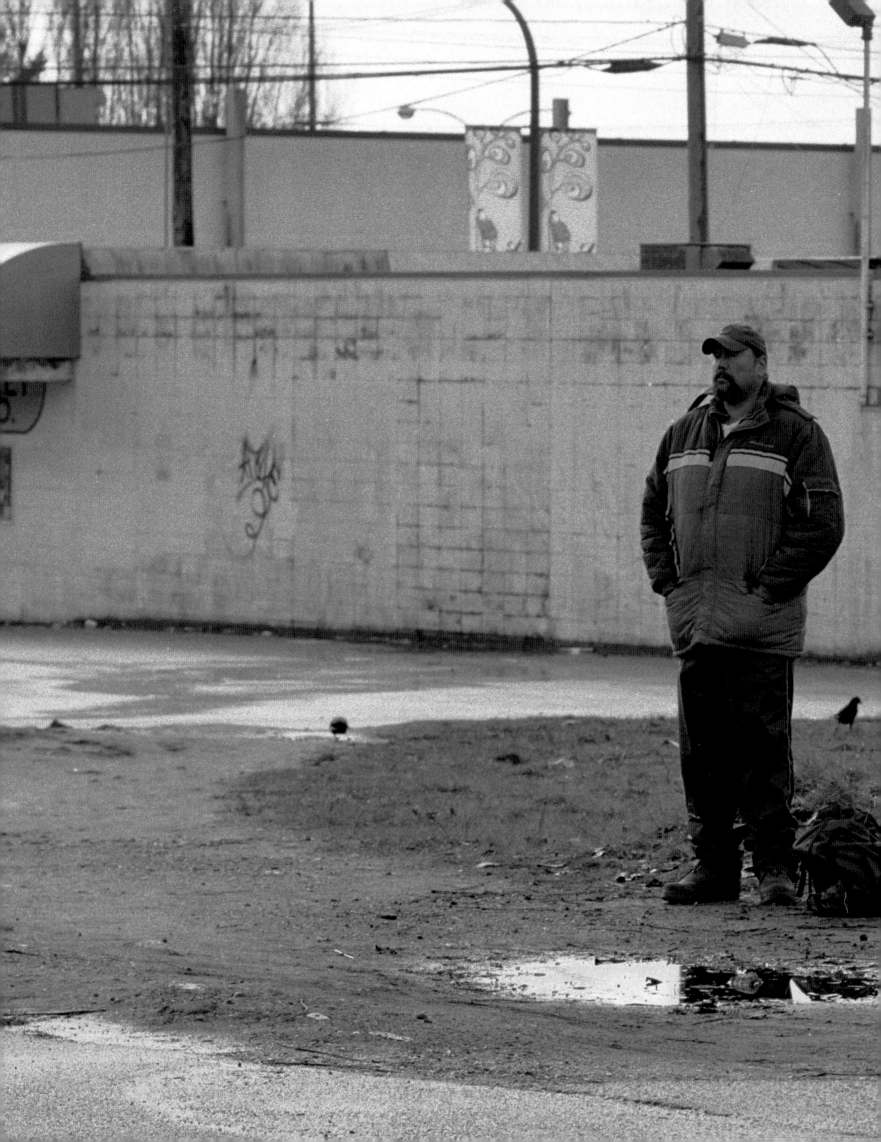

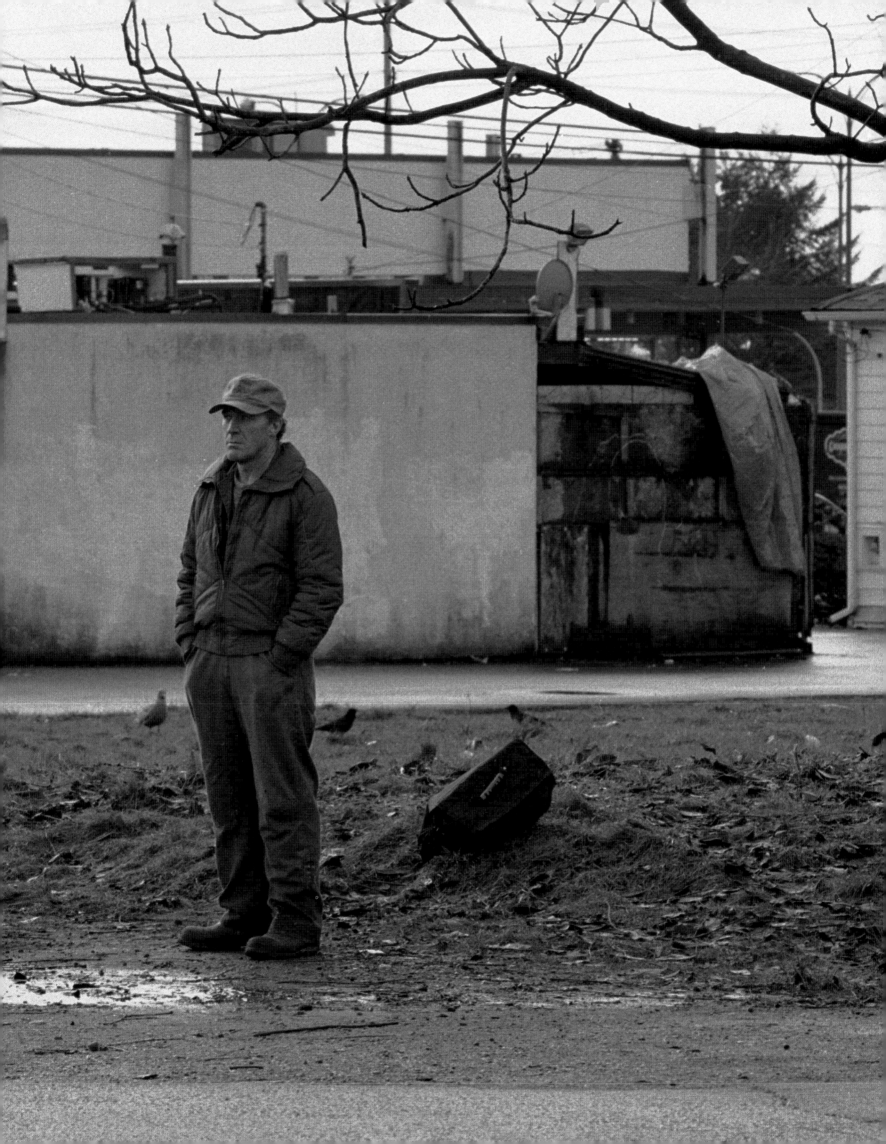

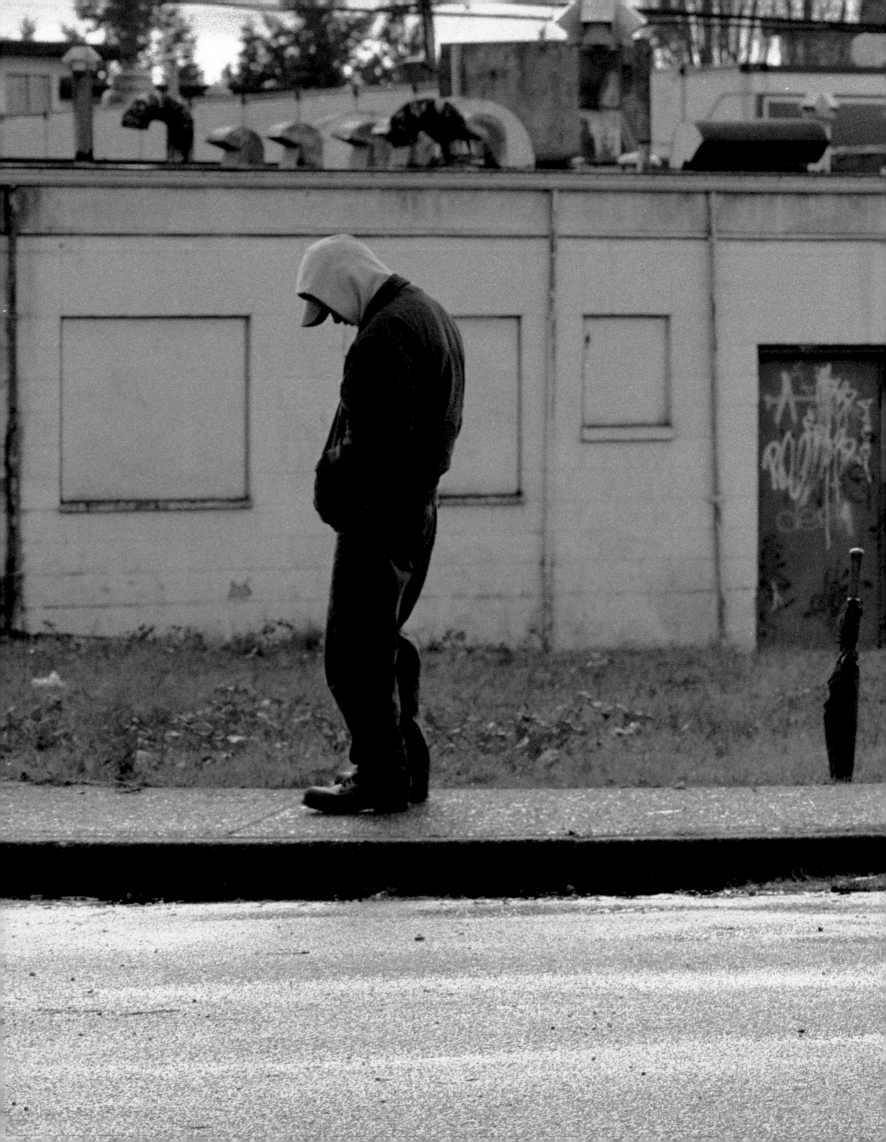

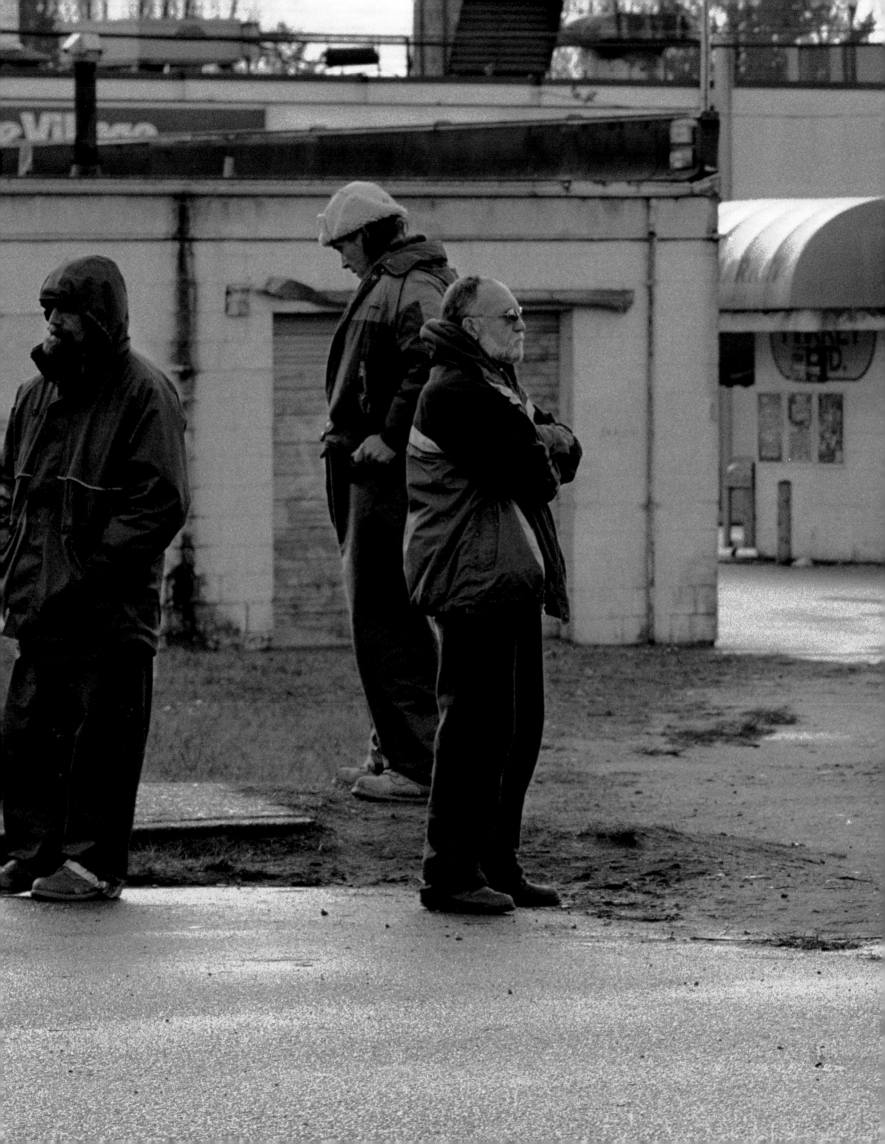

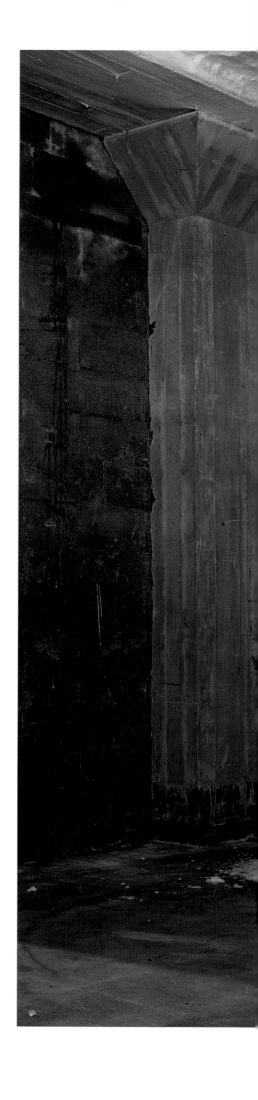

COLD STORAGE, VANCOUVER
2007
Gelatin-silver print
258.5 × 319 cm

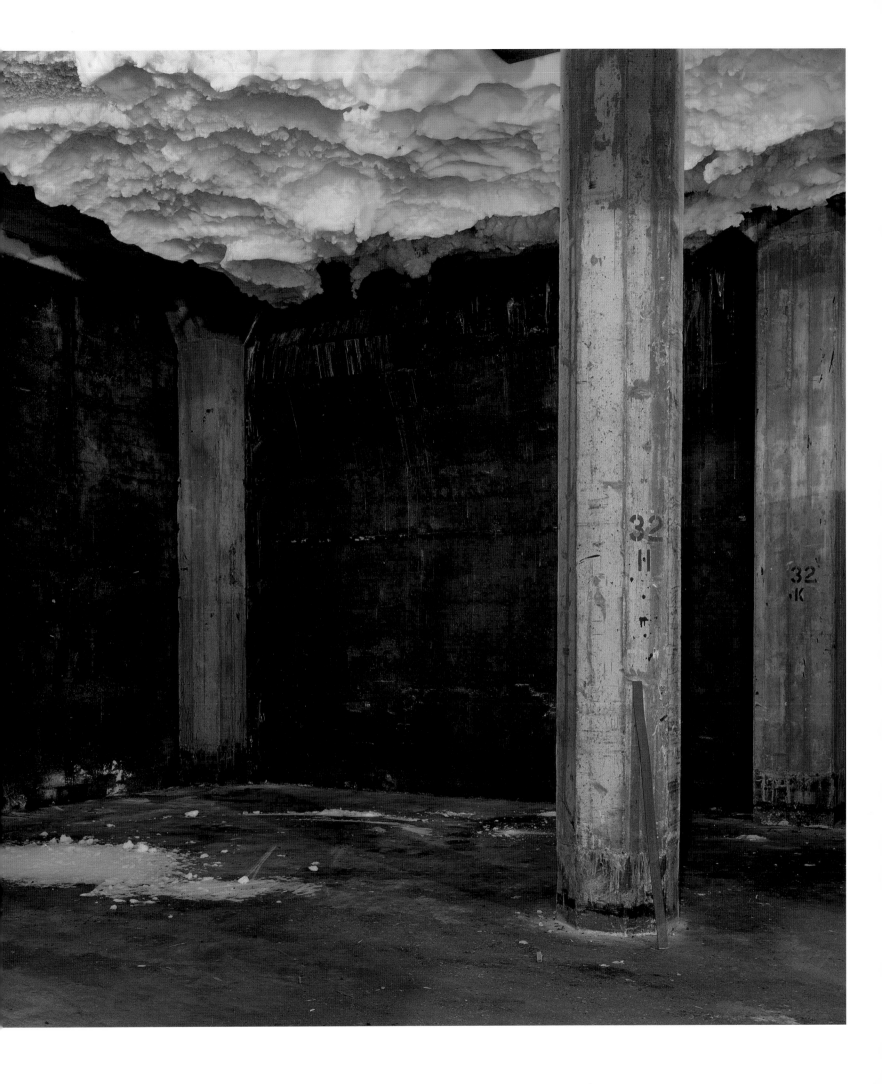

WAR GAME
2007
Gelatin-silver print
247 × 302.6 cm

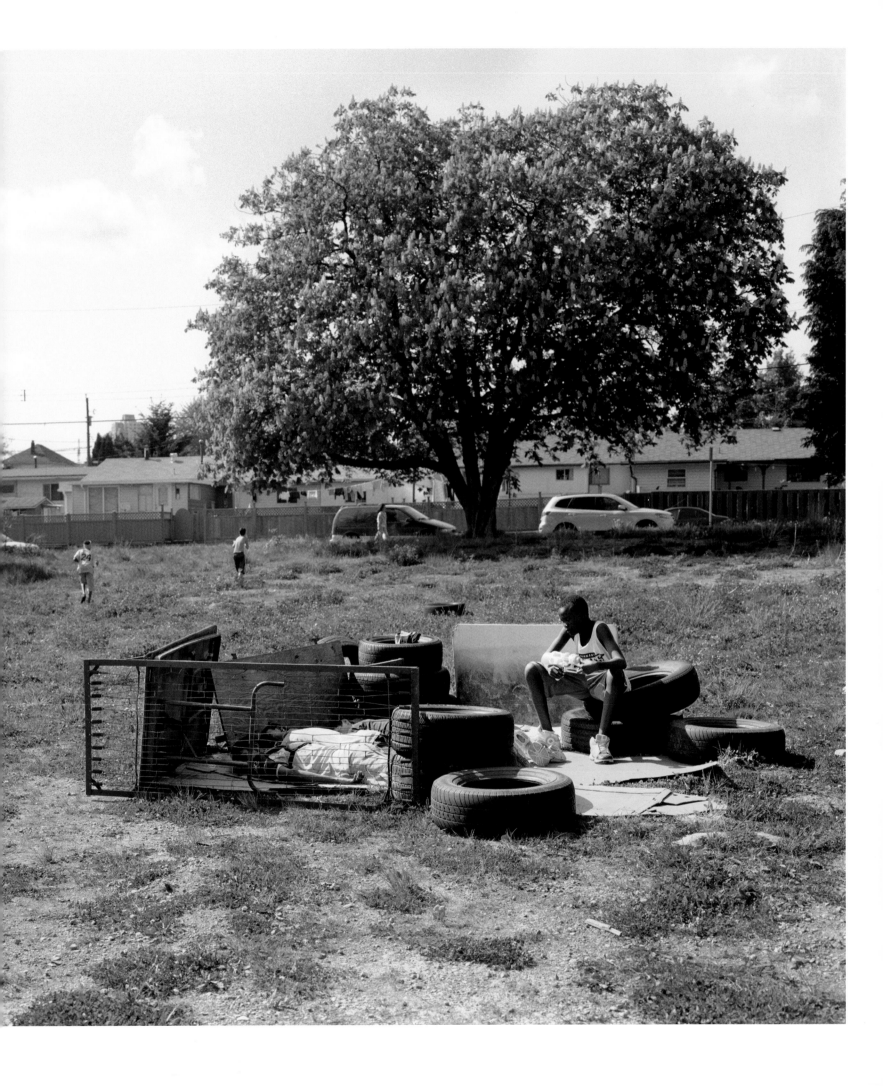

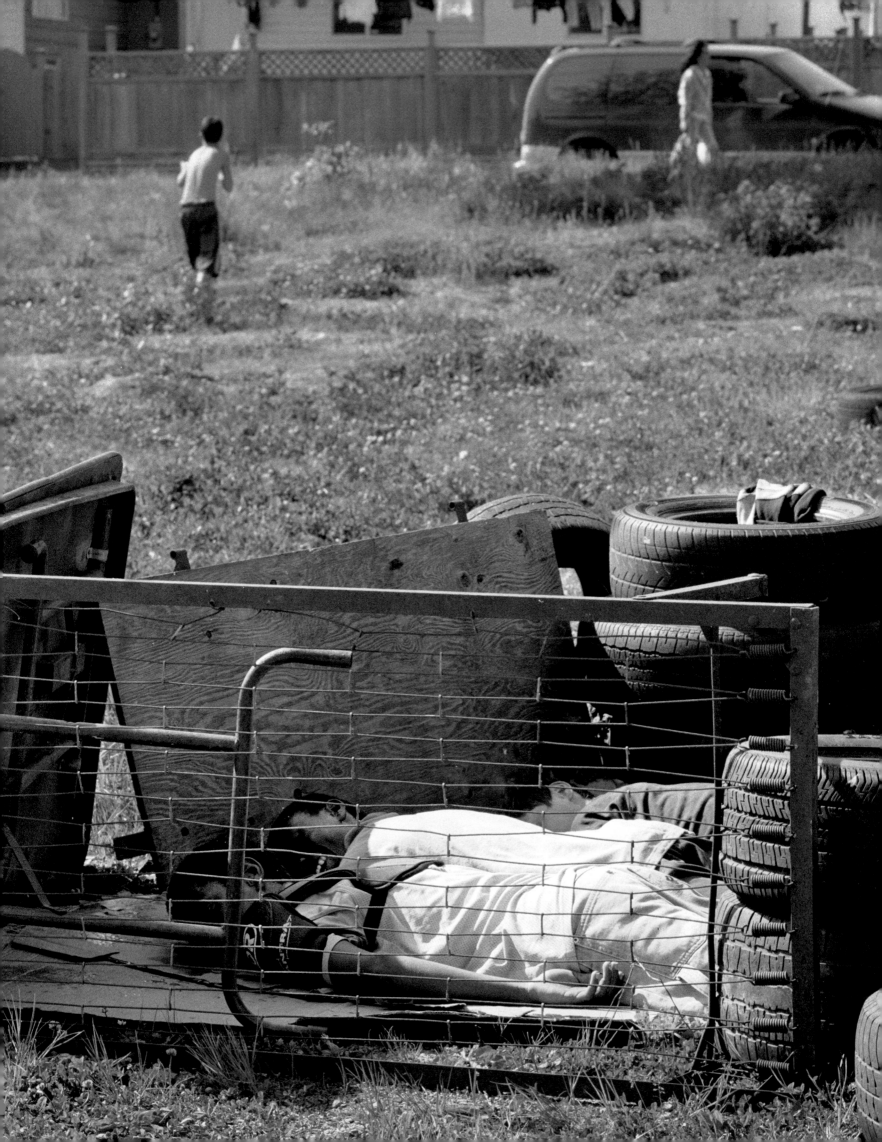

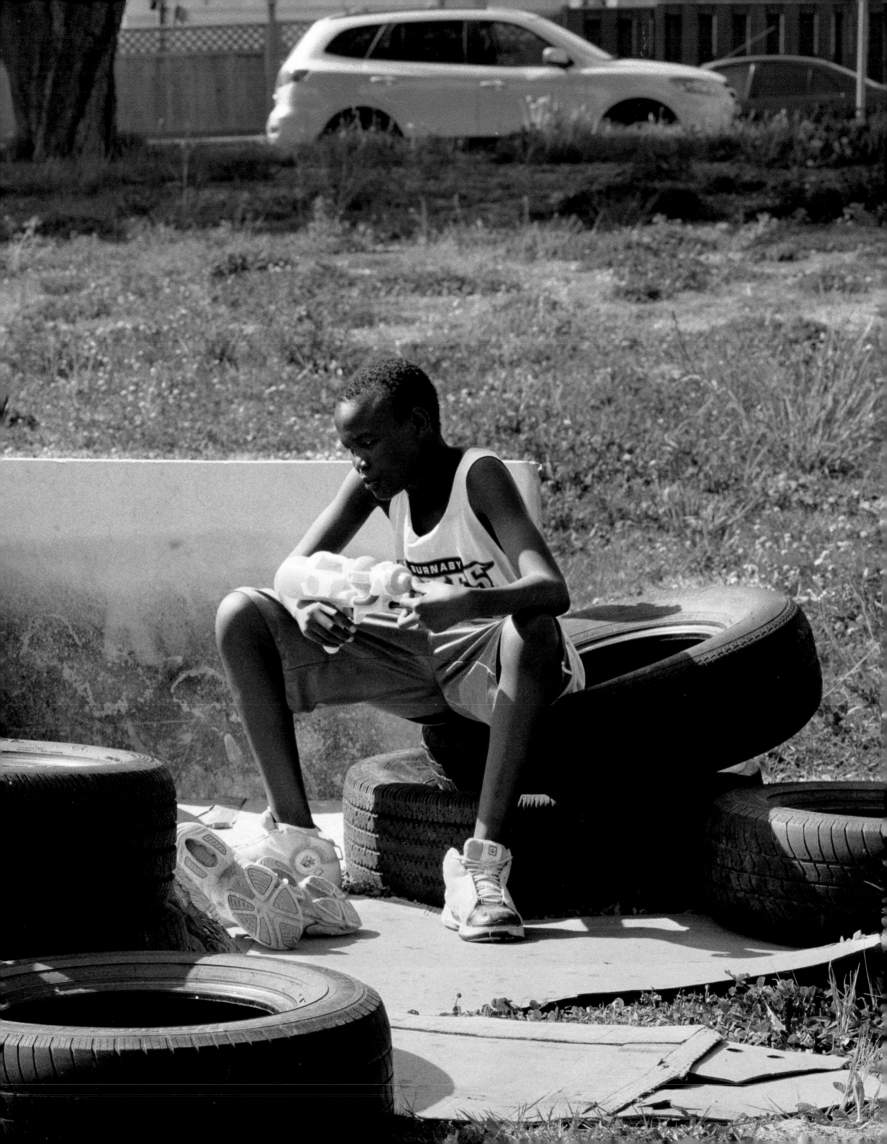

PASSING BY—THINKING
KATRIN BLUM

Standstill

So this is what life looks like in a quintessentially North American prefabricated house, a row house built of white and brown parts with three particularly notable elements:

First, the protruding central parts of the house rest on narrow metal pillars. The house on pillars (or piloti) is among the symbolic forms of Modern architecture and specifically tied to the movement's ideals. Le Corbusier wanted to rebuild Europe's congested cities on concrete pillars in order to gain space underneath the buildings for movement through-out the city, especially by car.[1] However, this was unnecessary in the large, sprawling American suburbs where lack of space was not an issue. In these developments, it was much more important for each house to have a driveway and a carport. The houses in Jeff Wall's cinematographic photograph *Tenants* (2007; pp. 38–39) are a good example of this kind of changed use for a house on piloti. In contrast to the architect's plans, the residents don't use the resulting space for parking their cars, but as additional outdoor living space. The point from which they were meant to go out into the world has become a place of retreat where they sit on garden chairs killing time. The car in front of one of the houses has been taken off the road, as we can tell from the absence of a license plate.

Second are the large windows, also among the symbolic forms of Modern architecture intended, in the rhetoric of Modernism, to let in light and air and thus to further residents' health and well-being, even their happiness. In *Tenants*, the windows are closed and the curtains are mostly drawn.

Third, despite these fundamentally modern elements, the house has non-modern features that mostly veil the building's economically motivated "construction-industry functionalism."[2] The angled ornamental trim with glued-on wooden shingles disguises the flat roof and hides the basic form of the building, which is most reminiscent of a transport con-tainer. This is an inexpensive way to evoke traditional Canadian wood architecture, as are the vertical strips on the façade which are, in fact, made of wood.

This image of eclectic discount architecture creates an atmosphere of retreat and stagnation. All four of the residents shown have retreated into a private sphere. They are all at home, even though it appears to be the middle of the day. Nevertheless, we are not told much about them. Wall puts the viewer into the position of a passerby who happens to walk past the row house without knowing anything about its occupants. This effect is produced by the "subjective," diagonally shifted angle from which the scene is viewed and by the distance Wall places between the viewer and the people photographed, which makes it impossible to get a more individual impression of them.

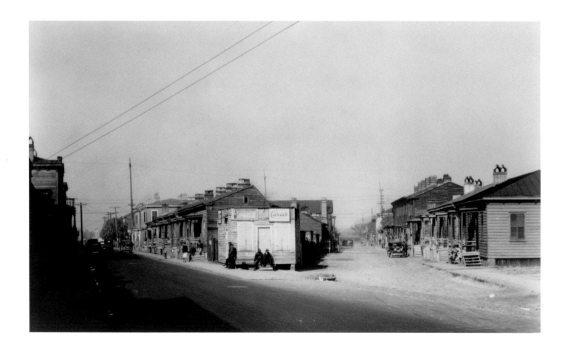

fig. 24 Walker Evans, *Savannah Negro Quarter,* 1935

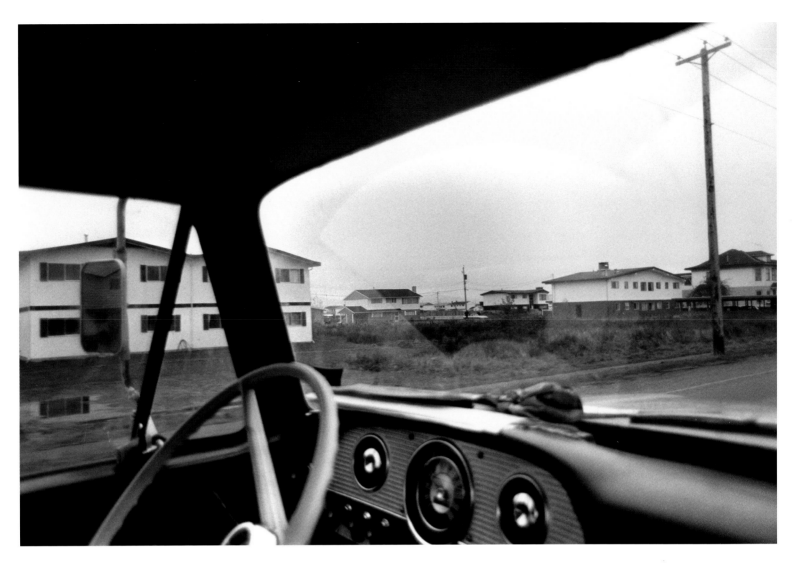

fig. 25 Jeff Wall, *After 'Landscape Manual'*, 1969/2003

As is well known, Wall's shots are usually preceded by extensive preparation. The images are staged—although the use of this term in relation to Wall's work is often unclear. It would be wrong to claim that most of his photographs are of props staged for the camera. Instead, Wall consciously searches and selects locations that are then narratively charged with people or objects.[3] Almost every detail in the resulting images is there because of a conscious decision by the photographer.

In *Tenants*, as in many of his works, Wall describes the people in the picture by means of their surroundings. In characterizing social settings in this way, Wall follows a long tradition in photography. Already in the early twentieth century, the medium was used to draw attention to precarious social conditions.[4] In the 1930s, Walker Evans photographed poor, working-class families on behalf of the Farm Security Administration, a government institution that set out to document the lives of poor rural workers in the American South during the Depression. The workers' houses and apartments served as emblems of their living conditions (see fig. 24). Beaumont Newhall writes: "Much of what Evans photographed was squalid, but his interpretation was always dignified."[5] Evans achieved this through a markedly aestheticized rendering of the dwellings and a respectful approach to the people portrayed. Wall leaves it up to the viewer to decide whether his image portrays middle-class people or those on the margins of society. To what extent can this be identified by a passerby who sees things from a distance? What are the outward signs of poverty and resignation— an unregistered vehicle, a cheap plastic chair, drawn curtains? The image underscores our desire to classify all we see, and how difficult such classifications really are.

The standardized suburban architecture featured in *Tenants* is a subject that has interested Wall since the beginning of his artistic career. In 1969 and 1970 he produced the photo booklet, *Landscape Manual*, in which he showed small black-and-white photographs of deserted suburbs and streets that had clearly been shot from a car window (fig. 25). Not unlike the conceptual artist Dan Graham, who in 1965 published a series of images titled *Homes for America*, Wall looked at how the landscape had been changed by the continuous spread of the suburbs. The effect of human intervention on the landscape was an important topic for photographic interpretation at the time; it was surveyed in 1975 in the influential exhibition *New Topographics: Photographs of a Man-Altered Landscape*, at the International Museum of Photography at George Eastman House in Rochester, New York. Neither Graham in *Homes for America*, nor Wall in *Landscape Manual*, were particularly concerned with the artistic craftsmanship of their images. In *Landscape Manual*, as in *Tenants*, Wall emphasized the subjective position of the viewer: in the earlier work, the fleeting gaze from a car window; in *Tenants*, the fleeting gaze of a distant passerby. However, unlike Wall's early work and thematic precursors, such as the photographs of Evans and Graham, *Tenants* assumes a much larger format and thus required far more effort to produce in terms of stage direction and the equipment involved.

Waiting for Movement

The elevation of "low" subjects by enlarging the scale of a work was an approach used in the nineteenth century by Gustave Courbet. His 1849 painting *A Burial at Ornans* (fig. 26), for example, which depicts a funeral in the artist's hometown with little noticeable hierarchy among the people shown, measures more than three by six meters. This genre scene is thus presented in the format of important historical paintings, thereby blurring the boundaries of academic genres. *A Burial at Ornans* was a provocation in other ways as well. Courbet's presentation

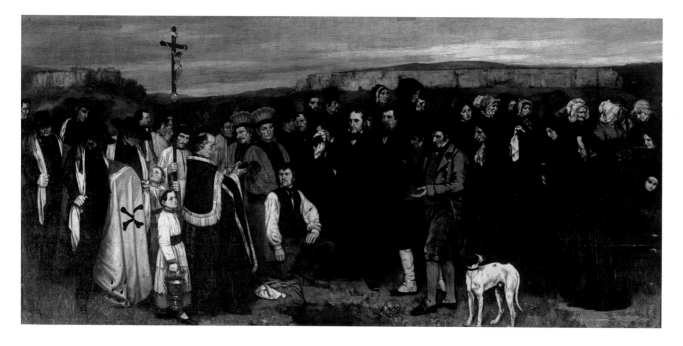

fig. 26 Gustave Courbet, *A Burial at Ornans*, 1849

of simple country folk as worthy artistic subjects was a controversial act: representatives of this social stratum had previously been tolerated only as peripheral figures in large-format paintings. Similarly, Wall's *Men waiting* (2006; pp. 40–41) shows twenty men standing by the side of a road, without a discernible hierarchy among them. Most are assembled in a loose group near the right edge of the image, next to a tall conifer. Others are spread out across the space, each in almost demonstrative isolation. Although the individuals don't seem to be talking to one another, they are perceived as a group nonetheless. The surroundings, consisting of a few low buildings, provide few clues as to the purpose of the gathering. It is the lack of communication between them that illustrates the meaning of the title: standing by the road is not an end in itself; they are all waiting for something.

Altogether, the men take up a noticeably small part of the image space. From a purely formal perspective, Wall arranged the image like a seventeenth-century Dutch landscape painting: he placed the gathering under a wide sky, partly cloudy and partly flooded with sunlight, that takes up about two-thirds of the image. The diversity of shapes and shades of gray found in the clouds is testimony to Wall's strong interest in rendering the sky with the greatest possible depth of focus and presence. In contrast to images by Dutch landscape painters such as Jan van Goyen (fig. 28), here the dynamic sky with its temporarily halted but constant changeability, emphasizes the men's inertia and motionlessness.

Despite a lack of clear indications, the men's age and clothing suggest that they are looking for work. Wall has confirmed that they are day laborers whom he hired at a "cash corner" in Vancouver. He claims to have then brought them to this location, which he preferred.[6] In other words, Wall staged the image, but, by placing the men by the side of the road, he staged them as who they already were.[7]

In Western industrialized societies, the day laborer is often considered a historical phenomenon. An image taken in Moscow around 1900 by an unknown photographer (fig. 27) shows day laborers waiting for work; the photograph was taken from the other side of the street in order to show the large number of people hoping for employment. To a certain extent, however, the phenomenon of the day laborer has always continued to exist in the form of short-term household employees and harvest workers, and in the context of globalization, day laborers are increasingly making a comeback. Rarely are they as noticeable as they are at North American "cash corners."

Despite the politically charged subject, it does not appear to be Wall's intention to comment on a social issue. *Men waiting* is not a political statement; again, it casts a distanced, rather coldly surveying gaze on its subject, not unlike that of a passerby who examines the group from across the street. Maybe some passersby are not interested in the men's fate at all, but rather enjoy the view of the vast sky overhead, instead. Because of this distancing of viewer and subject, it is possible to understand the image independent of the specific occasion—as either a general study of human behavior in groups, or as a theatrical staging of humans rigidly imprisoned in themselves, yearning for motion and change. This is suggested also by the title of the image, which is decidedly unspecific.

Movement

Wall's *Overpass* (2001; fig. 29) shows four people on a bridge. They are all carrying luggage and are heading for the other side. Their motion, emphasized by their heads being slightly bent forward, strongly contrasts with the stillness of the self-absorbed people in *Tenants* and *Men*

fig. 27 Unknown photographer, *Moscow: Labour Exchange near Kalantchevsko Square,* ca. 1900

waiting. Nevertheless, some elements recur, such as the drama of the storm clouds in the sky and the suburban or industrial settings. In both images, the common activity is the only thing that unites the subjects as a group. As in *Men waiting*, the people on the bridge don't seem to notice one another, and their destination is unknown. Again, the viewer is observing the passing group from a slight angle and a certain distance, which is just enough so that the viewer does not feel part of the movement. Again, it is difficult to place the people: it is unclear whether they are travelers, merchants, or even refugees. Again, Wall evades a clear interpretation, especially as the subjects' faces cannot be seen.

The movement of the characters is the decisive aspect of *Overpass*. It creates the impression of a snapshot. However, this photograph, like *Tenants* and *Men waiting*, was also preceded by intensive preparations, and the final image was altered digitally. Knowing about the staged nature of the photograph changes the viewer's perception. The motion of the woman on the left may suddenly be perceived as semi-frozen, as in a tableau vivant.[8] Furthermore, any detail could theoretically be viewed as a symbol, charged with meaning. The truck approaching from the right, for example, may become a "symbol *par excellence* of this type of meta-urban setting."[9] Like *Tenants* and *Men waiting*, *Overpass* is also an example of street photography, in the sense that the photograph was taken on the street. More than in the other two photographs, however, *Overpass* refers to the tradition of American street photography through stylistic references: Wall presents himself as an unnoticed, observing photographer who seems to spontaneously capture a chance moment.

In contrast to *Tenants* and *Men waiting*, *Overpass* is in color, like the greater part of Wall's work. The image is not only a statement on the contemporary human state of being en route, but also, with its various shades of blue and gray, a color study. It becomes clear that the composition of Wall's images is at least as important to him as the subject matter with its references to current societal discourses on migration, globalization, and mobility. The example of *Overpass* also demonstrates that the choice of black-and-white photography for *Tenants* and *Men waiting* was probably not primarily motivated by the subject matter. Though it would seem obvious to recognize in this choice a connection to social documentary photography by the likes of Dorothea Lange, who forcefully captured social ills in black and white, Wall's approach to his subject does not really vary according to the medium. First and foremost, black-and-white photography represents an expansion of his artistic possibilities.

Wall presents a silently staged life in suburbia as a world of retreat. He focuses on strong men who stand passively by the side of the road, waiting to be able to do something, and he sees people who rush from here to there. In his images of standstill, of waiting, and of movement, he places the spectator inside the image, positioning the viewer as a passerby who observes people fleetingly and begins to think about them. In this way, we seek to make sense of the actions of others, and we are preoccupied with determining our own position. It turns out that Wall's photographs put the viewer in motion first of all.

—Translated from the German by Phillip Angermeyer

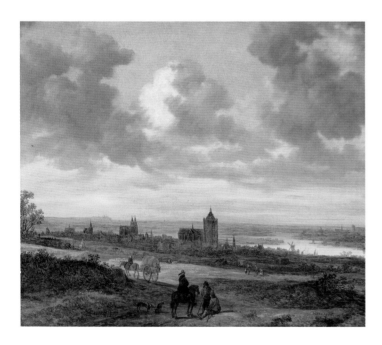

fig. 28 Jan van Goyen, *View of Arnheim*, 1646

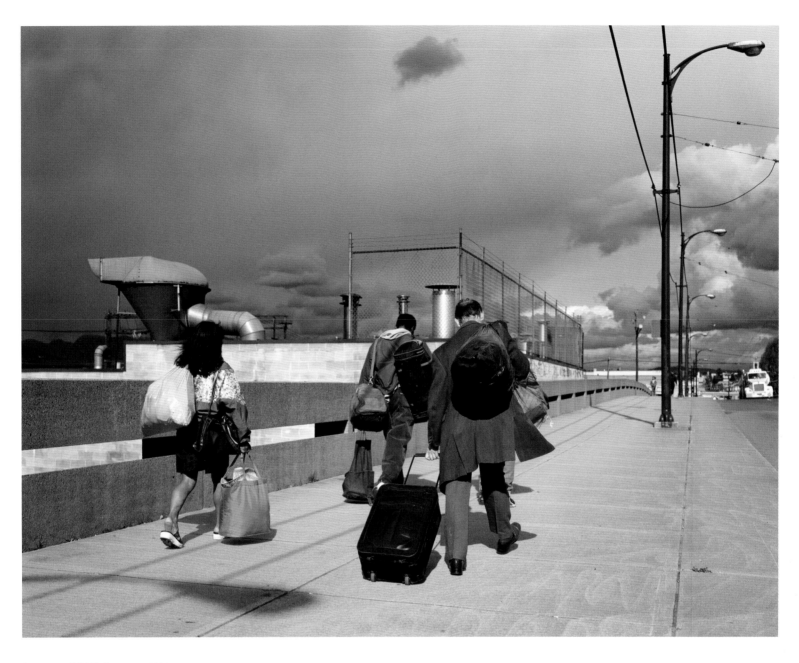

fig. 29 Jeff Wall, *Overpass*, 2001

NOTES

I owe thanks to Claudia Gochmann, Jennifer Knox White, and Jutta von Zitzewitz, and especially to Hans Georg Hiller von Gaertringen for corrections and inspiration. Furthermore, I would like to thank Stephen Waddell.

1. Le Corbusier's first project incorporating piloti was his Ville Contemporaine of 1922. The use of piloti in residential architecture was also popular in Southern countries. For example, the Brazilian architect Oscar Niemeyer, who was influenced by Le Corbusier, used them to offer residents outdoor space and protection from the sun. On piloti and their function in architecture, see William J. R. Curtis, *Le Corbusier: Ideas and Forms* (Oxford: Phaidon Press, 1986), pp. 72–84.

2. This term (*Bauwirtschaftsfunktionalismus*) was introduced by the architecture and art historian Heinrich Klotz in a paper he presented at a 1975 symposium on architecture at the International Design Center in Berlin. It was meant to draw a distinction between post-World War II architecture and the avant-garde Neues Bauen (New Building) of the 1920s. See Heinrich Klotz, "Das Pathos des Funktionalismus," in Klotz, *Architektur: Texte zur Geschichte, Theorie und Kritik des Bauens* (Ostfildern-Ruit, Germany: Hatje, 1996), p. 204; originally published in *Archithese* 3 (March 1977).

3. *Tenants* was created in Abbotsford, a city of approximately 150,000 inhabitants, located 70 kilometers south of Vancouver.

4. See, for example, the work of Jacob August Riis or Lewis Hine.

5. Beaumont Newhall, *The History of Photography* (New York: Museum of Modern Art, 1982), p. 238.

6. Arthur Lubow, "The Luminist," *New York Times Magazine*, February 25, 2007, pp. 56–63, 138, 140, 152–3. Lubow writes: "When I asked what interested him in the subject of day laborers, Wall told me that he was fascinated by 'the physical animal energy that is present on the street and waiting to be disposed of.'" The term "cash corner" describes a public space where people gather to be hired for short-term work.

7. See also the essay by Jennifer Blessing in this volume.

8. On gestures in Wall's work, see Gregor Stemmrich, "Between Exaltation and Musing Contemplation: Jeff Wall's Restitution of the Program of *peinture de la vie moderne*," in *Jeff Wall: Photographs*, exh. cat. (Vienna: Museum moderner Kunst Stiftung Ludwig Wien, 2003), pp. 140–157.

9. Charissa N. Terranova, "On the Hairy Idea of Beauty: Seven Works by Jeff Wall" (2003), http://www.stretcher.org/archives/e2_a/2003_03_20_e2_archive.php. On *Overpass*, see also Jean-François Chevrier, "The Spectres of the Everyday," in Thierry de Duve et al., *Jeff Wall*, 2nd ed., revised and expanded (London: Phaidon, 2002), p. 188.

EXHIBITION CHECKLIST

Night, 2001
Gelatin-silver print, 239 × 301.5 cm
Edition 2/2
Olbricht Collection
(p. 23)

Overpass, 2001
Transparency in lightbox, 214 × 273.5 cm
Edition 2/2
Telefonica's Contemporary Photography Collection
(p. 57)

Rainfilled suitcase, 2001
Transparency in lightbox, 64.5 × 80 cm
A.P. 1/2, Edition of 8
Collection of the artist
(p. 31)

Concrete ball, 2002
Transparency in lightbox, 204 x 260 cm
Edition 3/3
Courtesy Marian Goodman Gallery,
New York
(p. 32)

Logs, 2002
Gelatin-silver print, 167.5 × 209.5 cm
Edition 1/4
Courtesy Marian Goodman Gallery,
New York
(p. 33)

The following works, which are featured in the plates,
were commissioned by the Deutsche Bank in consulta-
tion with the Solomon R. Guggenheim Foundation for the
Deutsche Guggenheim, Berlin:

Men waiting, 2006
Gelatin-silver print, 262 × 388 cm
Edition 1/3
(pp. 40–41; 42–45 details)

Cold storage, Vancouver, 2007
Gelatin-silver print, 258.5 × 319 cm
Edition 1/4
(pp. 46–47)

Tenants, 2007
Gelatin-silver print, 255.4 × 335.3 cm
Edition 1/3
(pp. 38–39; 36–37 detail)

War game, 2007
Gelatin-silver print, 247 × 302.6 cm
Edition 1/3
(pp. 48–49; 50–51 detail)

LIST OF ILLUSTRATIONS

*The illustration checklist that follows includes owner
information for works by Jeff Wall that were produced in
editions of two or fewer.*

*Dimensions are given in centimeters, height preceding
width, and in the case of works by Wall, are those of the
image, not including light boxes or other mountings.*

Fig. 1
Eugène Delacroix, *Death of Sardanapalus*, 1827
Oil on canvas, 392 × 496 cm
Musée du Louvre, Paris

Fig. 2
Jeff Wall, *The Destroyed Room*, 1978
Transparency in lightbox, 159 × 234 cm
Unique
National Gallery of Canada, Ottawa

Fig. 3
Édouard Manet, *A Bar at the Folies-Bergère*, 1882
Oil on canvas, 96 × 130 cm
Courtauld Institute of Art, London

Fig. 4
Jeff Wall, *Picture for Women*, 1979
Transparency in lightbox, 142.5 × 204.5 cm,
Unique
Centre Georges Pompidou, Paris, Musée National
d'Art Moderne /Centre de création industrielle

Fig. 5
Jeff Wall, *Mimic*, 1982
Transparency in lightbox, 198 × 228.5 cm
Unique
The Ydessa Hendeles Art Foundation, Toronto

Fig. 6
Jeff Wall, *Swept*, 1995
Transparency in lightbox, 174 × 216 cm,
Edition of 2
Hamburger Kunsthalle; Private Collection, Basel

Fig. 7
Jeff Wall, *Some Beans*, 1990
Transparency in lightbox, 182 × 229 cm,
Edition of 2
Goetz Collection, Munich; Kröller-Müller Museum,
Otterlo, The Netherlands

Fig. 8
Jeff Wall, *An Octopus*, 1990
Transparency in lightbox, 182 × 229 cm
Edition of 2
Collection Fondation Cartier pour l'art
contemporain, Paris; Private Collection,
Switzerland

Fig. 9
Jeff Wall, *Volunteer*, 1996
Gelatin-silver print, 221.5 × 313 cm
Edition of 2
Emanuel Hoffmann Foundation, on permanent
loan to the Öffentliche Kunstsammlung Basel;
Sender Collection, New York

Fig. 10
Vittorio De Sica, still from *The Bicycle Thief*, 1948

Fig. 11
Jeff Wall, *Cyclist*, 1996
Gelatin-silver print, 229 × 302.5 cm
Edition of 2
De Pont museum voor hedendaagse kunst,
Tilburg; Private Collection, Munich

Fig. 12
Jean Renoir, still from *The Rules of the Game*, 1939

Fig. 13
Jeff Wall, *Night*, 2001
Gelatin-silver print, 239 × 301.5 cm
Edition of 2
High Museum of Art, Atlanta: Purchase with
funds from the High Museum of Art Enhancement
Fund; Olbricht Collection

Fig. 14
Chris Marker, still from *La Jetée*, 1962

Fig. 15
Jeff Wall, *A man with a rifle*, 2000
Transparency in lightbox, 226 × 289 cm
Edition of 2
Collection Martin Z. Margulies, Miami; Museum
Moderner Kunst Stiftung Ludwig Wien, Loan of
the Österreichischen Ludwig Stiftung

Fig. 16
Jeff Wall, *The Goat*, 1989
Transparency in lightbox, 229 × 308 cm
Unique
Collection, Art Gallery of Ontario, Toronto

Fig. 17
Jeff Wall, *Passerby*, 1996
Gelatin-silver print, 250 × 339.5 cm
Edition of 2
Collection of Chara Schreyer, San Francisco;
Kunstmuseum Wolfsburg

Fig. 18
Jeff Wall, *Bloodstained garment*, 2003
Transparency in lightbox, 139 × 176.5 cm
Edition of 5

Fig. 19
Jeff Wall, *Dawn*, 2001
Transparency in lightbox, 230 × 293 cm
Edition of 2
Collection Ringier; Collection Zellweger Luwa AG

Fig. 20
Jeff Wall, *Peas and Sauce*, 1999
Transparency in lightbox, 49 × 61 cm,
Edition of 8

Fig. 21
Jeff Wall, *Rainfilled suitcase*, 2001
Transparency in lightbox, 64.5 × 80 cm
Edition of 8

Fig. 22
Jeff Wall, *Concrete ball*, 2002
Transparency in lightbox, 204 × 260 cm
Edition of 3

Fig. 23
Jeff Wall, *Logs*, 2002
Gelatin-silver print, 167.5 × 209.5 cm
Edition of 4

Fig. 24
Walker Evans, *Savannah Negro Quarter*, 1935
Gelatin-silver print, 14.2 × 24.3 cm

Fig. 25
Jeff Wall, *After 'Landscape Manual'*, 1969/2003
Gelatin-silver print, 25.5 × 38 cm
Edition of 10

Fig. 26
Gustave Courbet, *A Burial at Ornans*, 1849
Oil on canvas, 314 × 663 cm
Musée d'Orsay, Paris

Fig. 27
Unknown photographer, *Moscow: Labour
Exchange near Kalantchevsko Square*, ca. 1900

Fig. 28
Jan van Goyen, *View of Arnheim*, 1646
Oil on canvas, 90 × 105 cm
Gemäldegalerie, Staatliche Museen zu Berlin,
Berlin

Fig. 29
Jeff Wall, *Overpass*, 2001
Transparency in lightbox, 214 × 273.5 cm
Edition of 2
Telefonica's Contemporary Photography
Collection; La Colección Jumex, Mexico